Voices of Light

Voices of Light

Yousef Khanfar

Foreword by
Ken Whitmire

Excerpts from the writings of
Yousef Khanfar

First Edition
HARDCOVER EDITION ISBN 0-929116-84-4

Publisher
Sherman Hines

Editor
Safari Knight

Graphic Design
Don Clark

Portfolio and Limited Edition Prints
Yousef Khanfar
6957 Northwest Expressway, Suite 219
Oklahoma City, Oklahoma 73132

Published By
Proguide Publishing, 659 Poplar Grove Rd.
Poplar Grove, NS, Canada B0N 2A0
Printed in Hong Kong

To
The beautiful lady and the gentleman
That named me
"Yousef"

In Memory of
My Parents

Deeb Khanfar
Bahia Khanfar

An Arabian Photographer

Out of the Arabian Peninsula, came a lone and landless photographer who has listened to and chased the light like an animal and a predator for over twenty years. He has created a breath-taking and dazzling body of work.

Yousef Khanfar is a Palestinian, born and raised in Kuwait. His parents were driven out of Palestine; their land and home were taken. He has never seen his homeland, so all landscapes have become his land.

While growing up in Kuwait and the Middle East, war events were his surroundings. All he saw on television or read in the newspaper were stories of bombing, bloodshed, and killing. Yousef was exposed to this constantly. Photography became his escape.

Yousef was introduced to photography as a young boy. He received his first camera from his father, an admirer of photography. Yousef remembers taking his first photographs when he was at the age of six and developing them in the darkroom with his older brother. He took his camera to the sand dunes to explore and photograph. In Kuwait, most of the landscape is sand dunes, nature's provision of soft silence.

Later, the bookstore offered him a new avenue of exploration. There he read many books on poetry, travel and photography. As he looked through books of American and European landscapes, he would think, "These must be paintings." He could not believe there was such a diversity of landscape and wondered why Kuwait did not have such land. His young fascination with this beautiful world grew into a lifelong photographic passion.

Photography became an integral part of his education. In addition, Yousef's study of painting exposed him to the European masters. With painting, he learned how to express his feelings through strokes of the brush onto the canvas. And today, he still paints with his lenses. He loves to photograph the world he missed and hoped to have while growing up in the Middle East. He continues to search for images that convey hope, peace, and tranquility.

Yousef's approach to photography is simple within a complex process. His use of the large format view camera allows him to slow down and visualize the final print. In painting his images, he searches for the right elements in nature; composes, and waits for the light to shine inside his heart, soul and mind. At that moment, when the light whispers to his lens, he captures it. In a recent workshop, Yousef emphasized, "Don't just wait for the outside light to shine, you must wait for the light within yourself… take it in… internalize it."

Yousef also found inspiration in the works of many masters of photography. He admires Minor White's philosophy, Edward Weston's composition, and Wynn Bullock's mysterious images. Throughout the years, Yousef has spent numerous hours mastering his technical ability. His belief is that technique is something you must learn and practice until it becomes second nature. Polished skills afford you more time on the design and composition of the final image.

In viewing Yousef's prints, you will experience images that are unique in spiritual energy and a quiet magic flows from within. Yousef appreciates a deep bond with nature and experiences oneness with the land. He perceives Lady Nature as beautiful, seductive, and feminine. He writes for her as he cherishes quiet moments in her arms.

Another very important and influential lady in Yousef's life was his dear mother. Some of the photographs selected for this book were printed after she lost her battle with cancer. The anger and chaos that he felt at that time are apparent in the passionate strength shown when he photographed and printed *"Touch Me Light."* The loss occurred one month before Yousef's major exhibit opening at the Photography Hall of Fame Museum.

Through Yousef's Arabian eyes, we see *"Voices of Light."* His images are as mysterious and elusive as the photographer himself. In addition, the poetry selections from his diary enlarge the images as much as the images enlarge the poetry. Collectors and admirers are drawn to the emotional depth and intellectual challenge of his creations.

Ken Whitmire
President,
Photography Hall of Fame and Museum

If photography is my language,
then light is my alphabet.

Listen To The Light

Light is my friend; we travel, share secrets and dance together. Often, I am jealous, how high and how far light can reach. Light reaches to the highest mountain peaks and to the distant planets. Light touches so many people and so many places. I wonder what the light sees and how it feels? Light is the everlasting soul of art.

Light is also my tool as much as my camera; I cannot use one without the other. Not only does light illuminate our surroundings; light is also energy, a force and an entity that stands on its own. To photograph is to see the light, with your eyes and with your heart. The more you know the light, the more you can control form, texture, tonality and mood.

Photography and light inspire my journeys over great distances to incredibly quiet and spectacular landscapes. Since I was a young boy, the light has fascinated me. I would stand mesmerized for hours while watching the light dance with the sand dunes. Though I could not hear their song, the light would dip and the dune would sway, as if rehearsing for an opening play. I learned to listen and observe the light in the silent forests, rivers, and skies. Silence is the means that can penetrate the mind and free it from contamination.

Through the years, my love and passion for light and life has become even stronger. I believe we all need the outside world to satisfy the inside world. They both become one world, with two different experiences and mysteries. And, it is through the magic of photography that I am able to chase, dance with, and capture the *"Voices of Light."*

Yousef Khanfar

We do not own the photographs,
we only borrow from the gods.

An Invitation

The Plates

Ride the voyage of light.
Become one with the light.
Become the light.

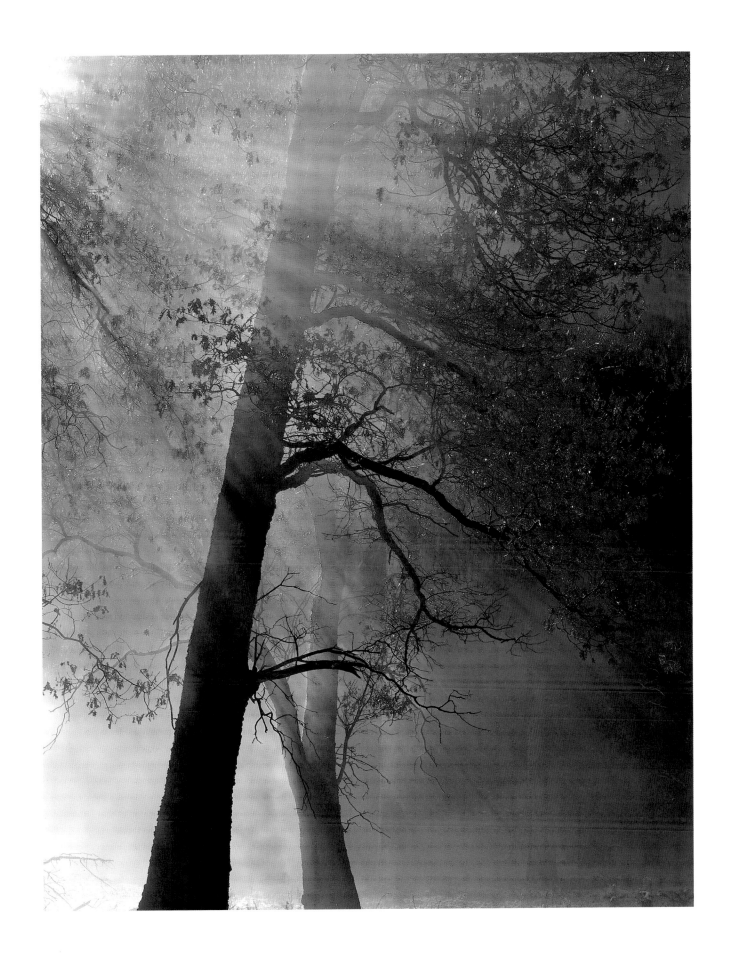

TOUCH ME LIGHT

PLATE 1

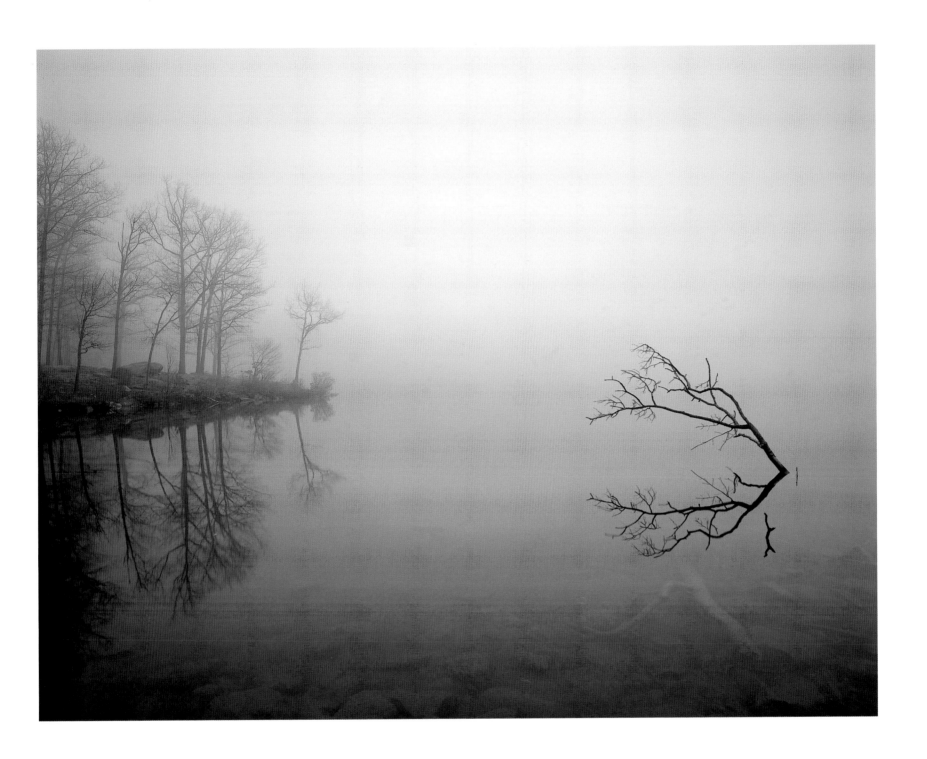

INTO THE DEEP

PLATE 2

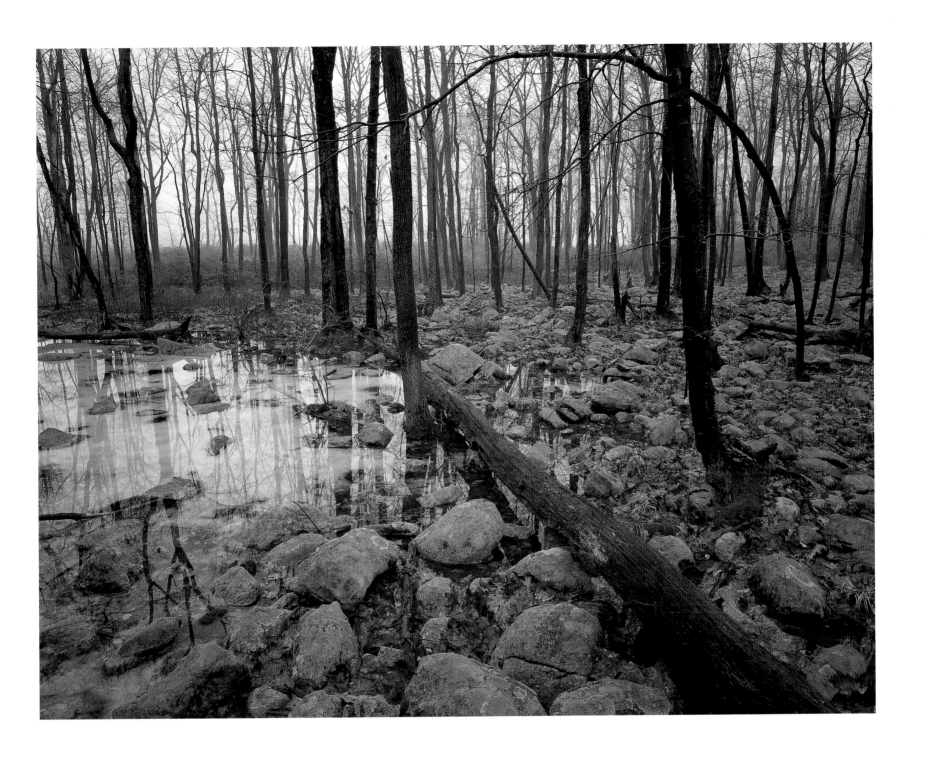

THE LAND LEGACY

PLATE 3

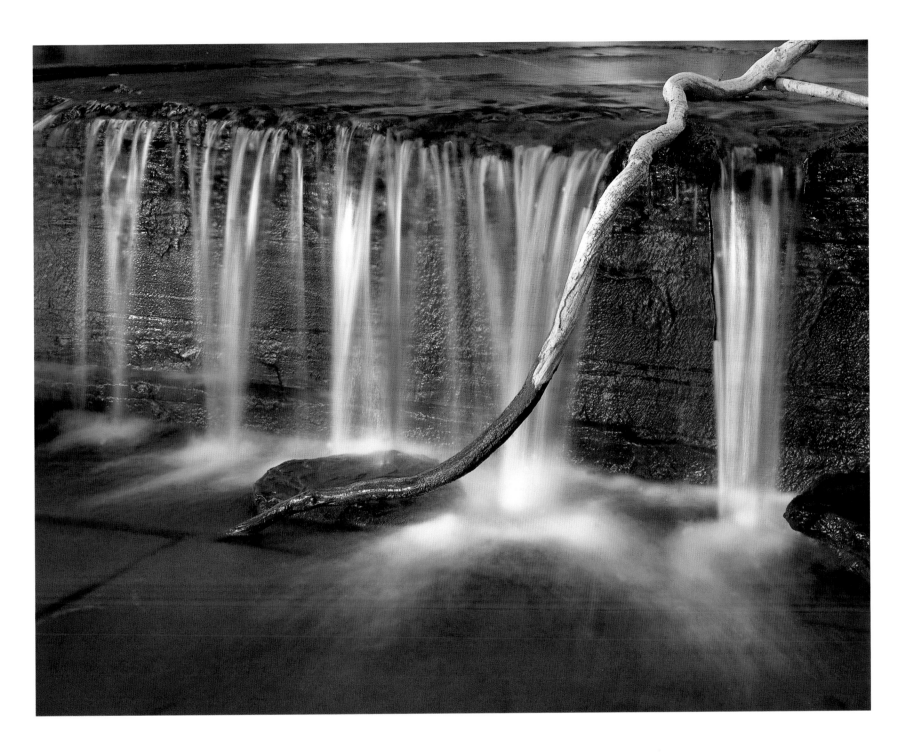

CASCADING

PLATE 4

I respect what you say
 in your silence.
I feel your wisdom
 in your silence.
I learn from you
 in your silence.
I feel your pain
 in your silence.

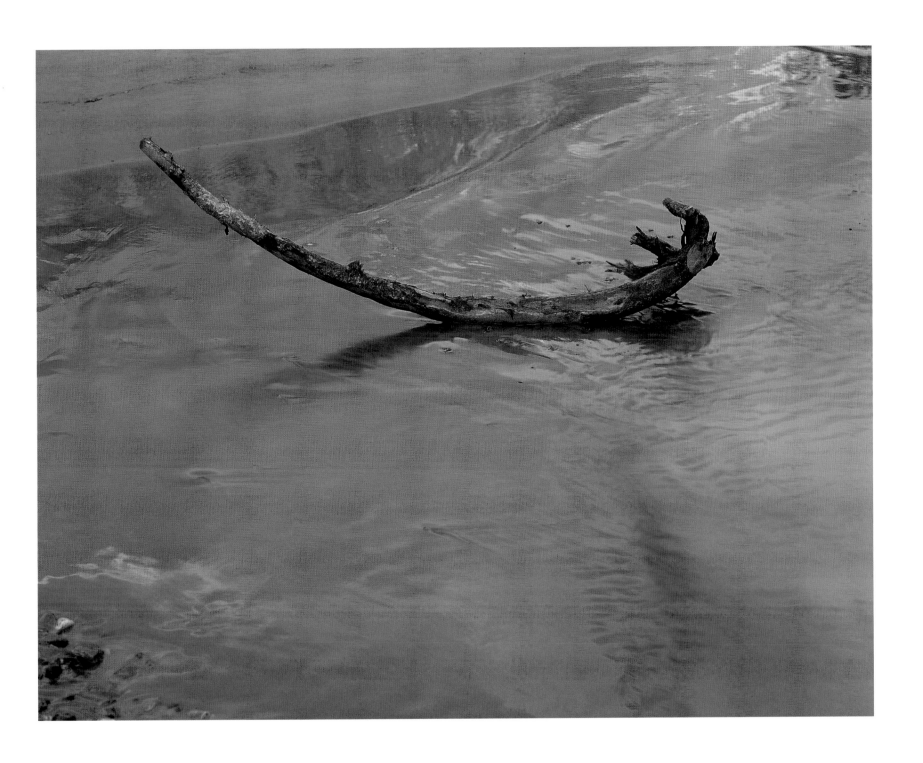

DANCING IN GOLDEN SATIN

PLATE 5

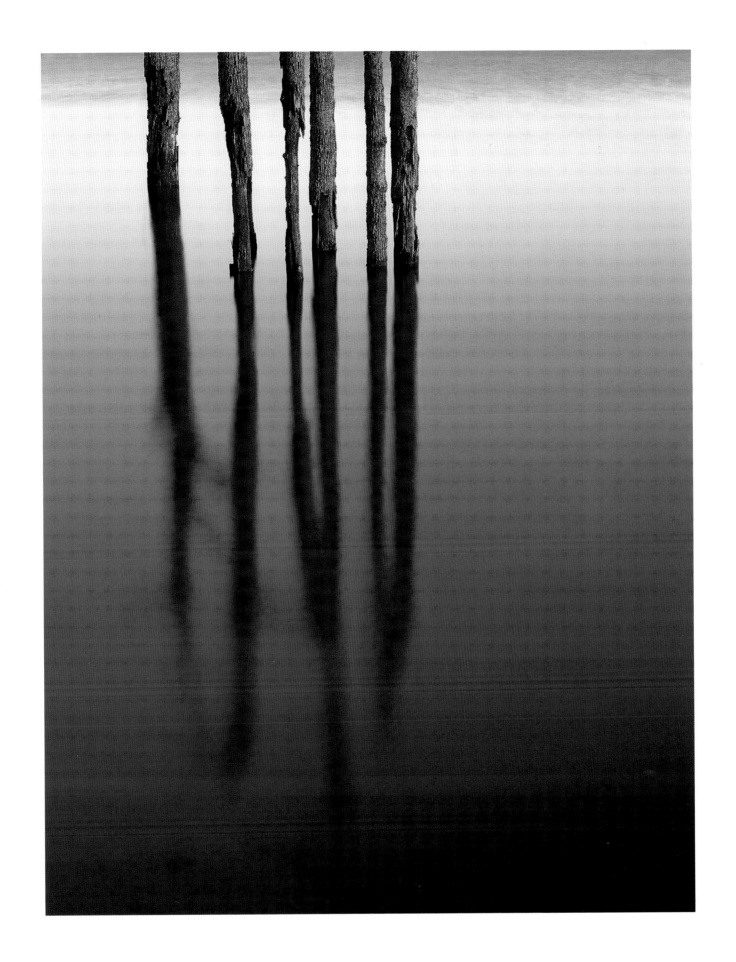

LOST IN THE BLUES

PLATE 6

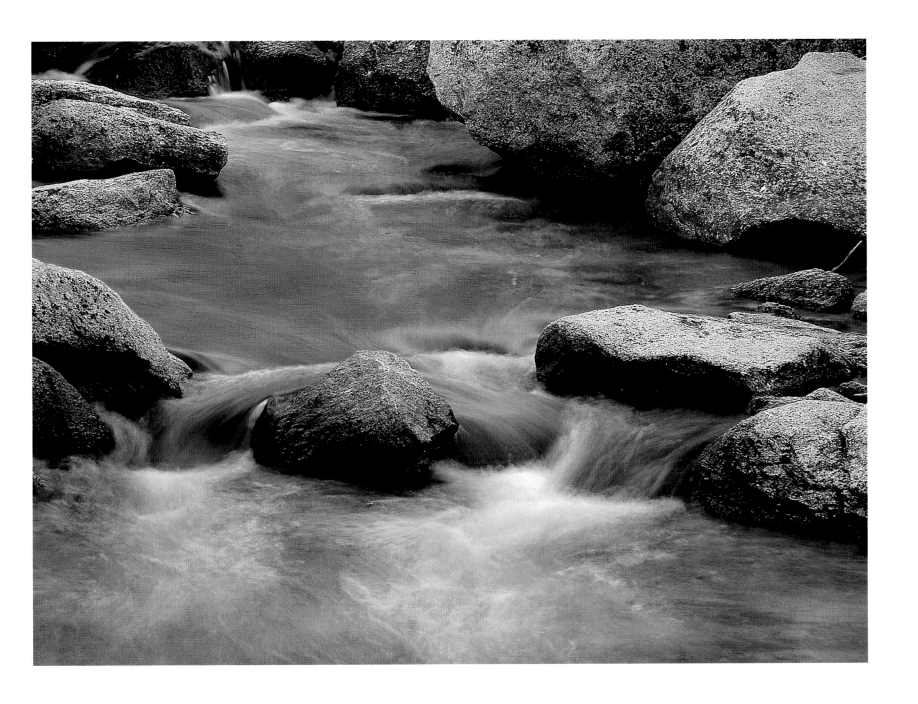

SUN SIGNATURE

PLATE 7

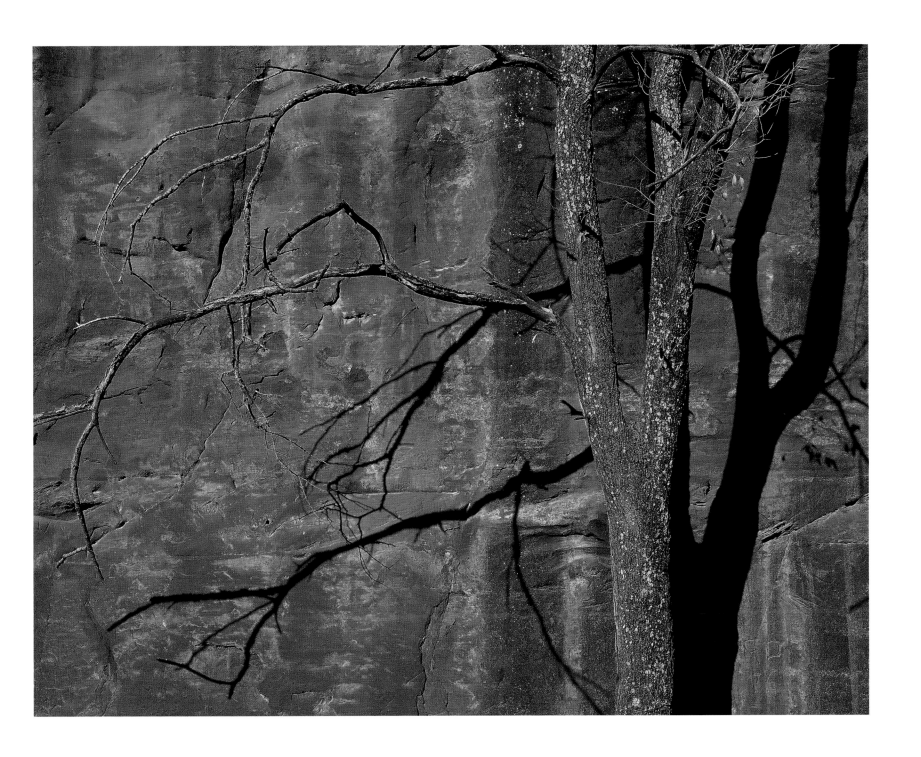

SHADOW SOUL

PLATE 8

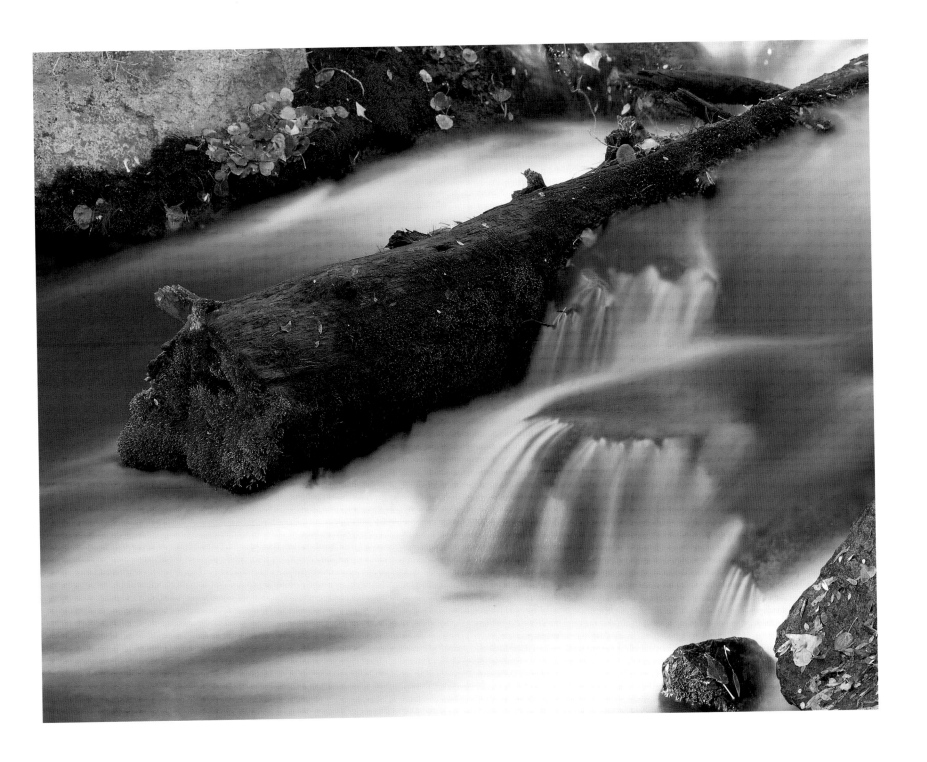

SOFTLY FLOWS

PLATE 9

Light is for
the dreamers
and the lovers.

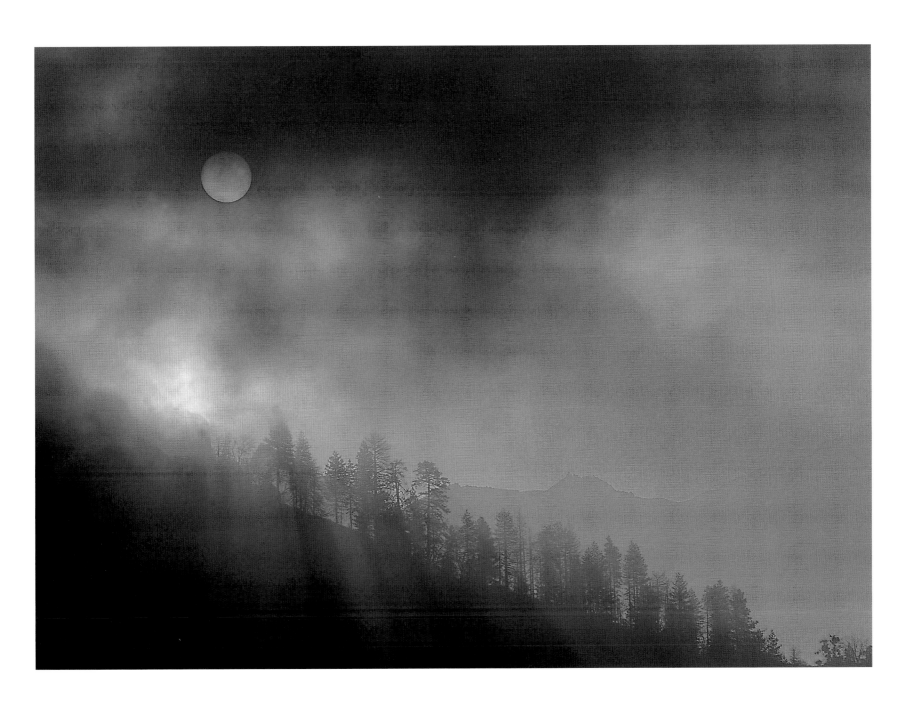

THE PHANTOM LIGHT

PLATE 10

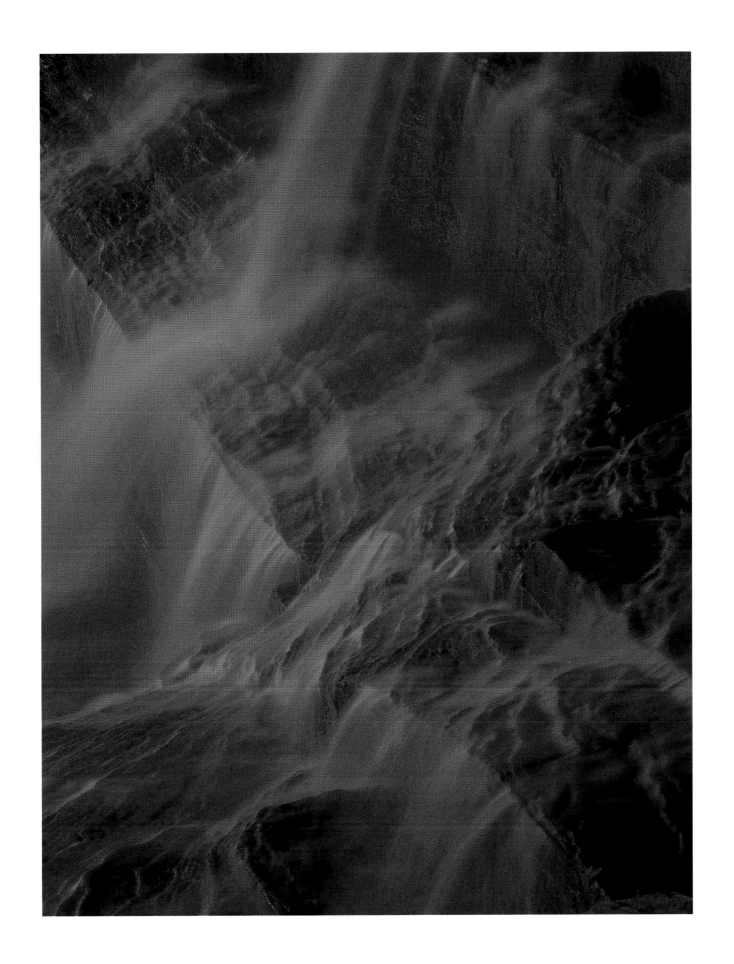

ROMANTIC FALLS

PLATE 11

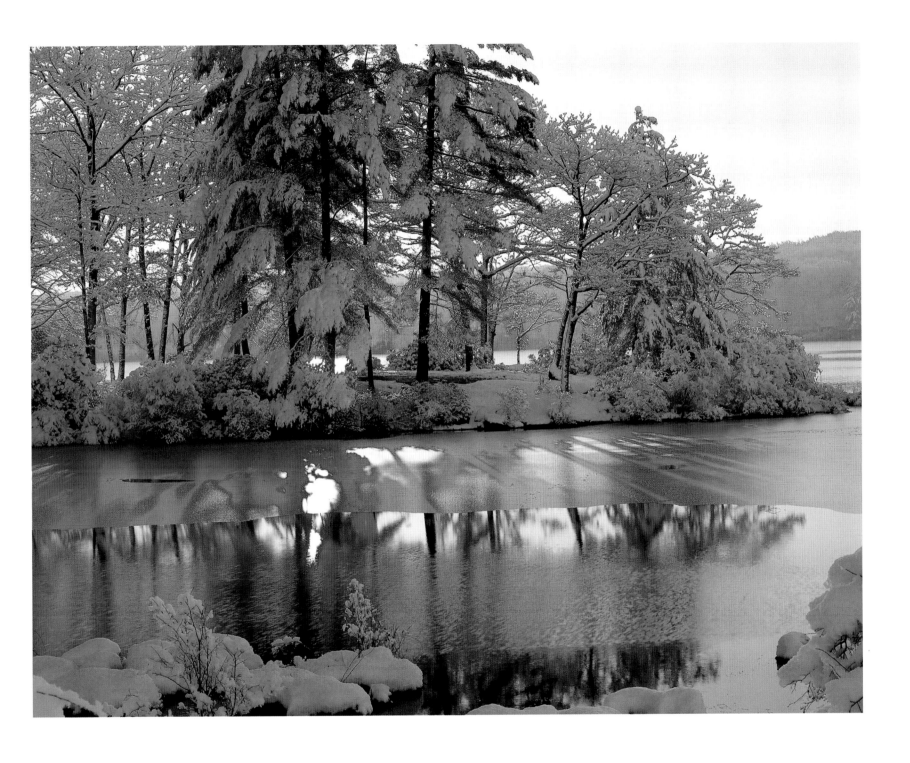

MY TREE

PLATE 12

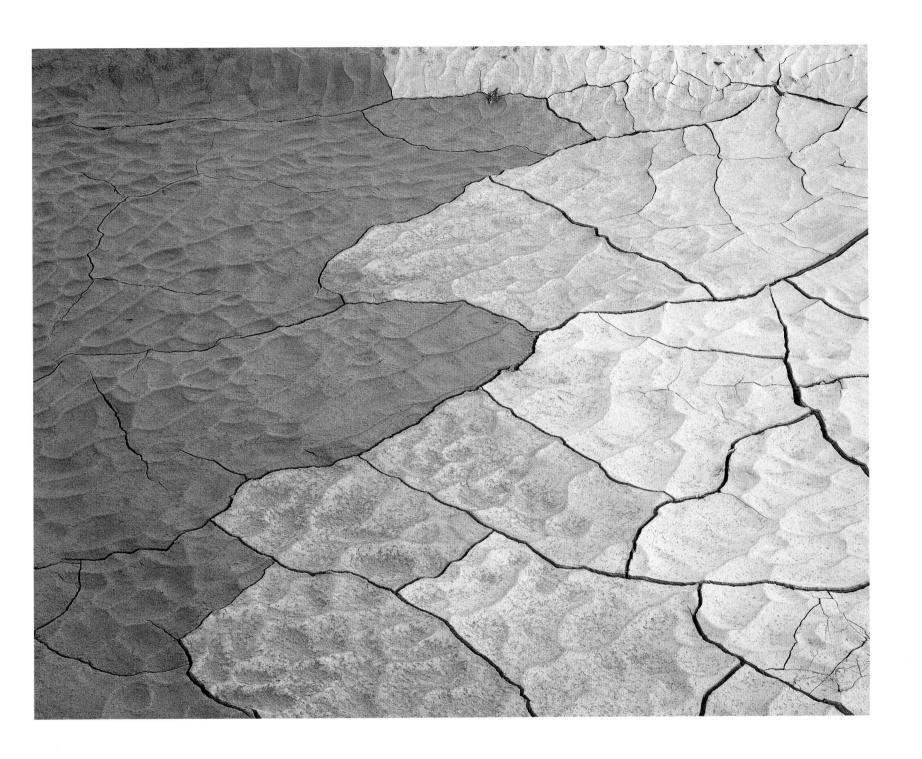

THE KISS

PLATE 13

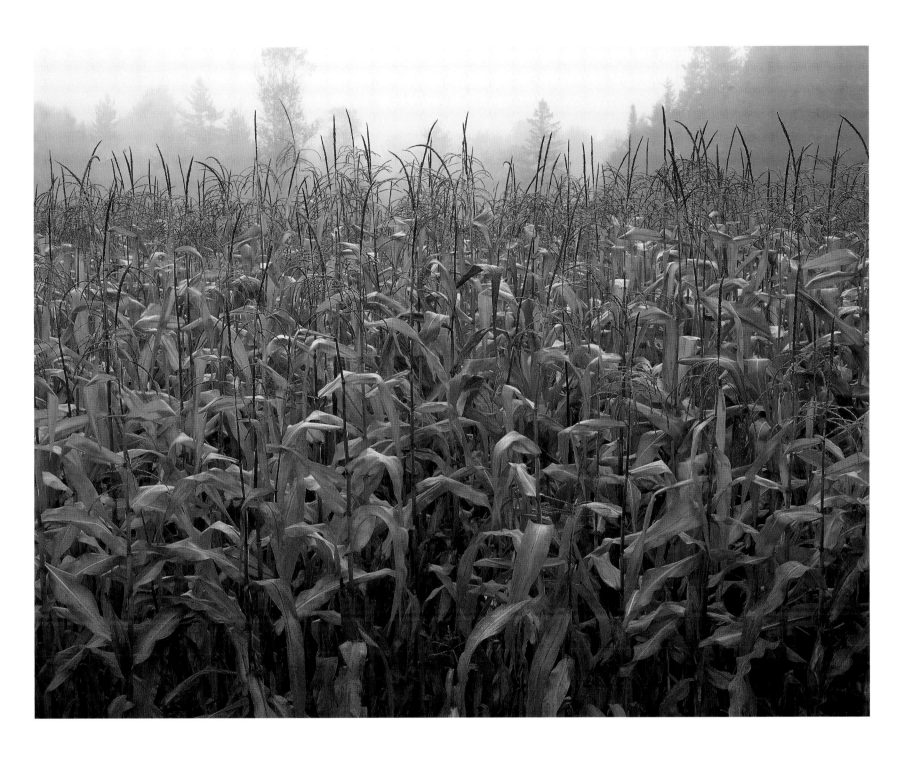

THE GOLDEN FIELD

PLATE 14

In the forest of your femininity... I dream.
On your luscious lips... I dance.
At the edge of your eyelashes... I sleep.

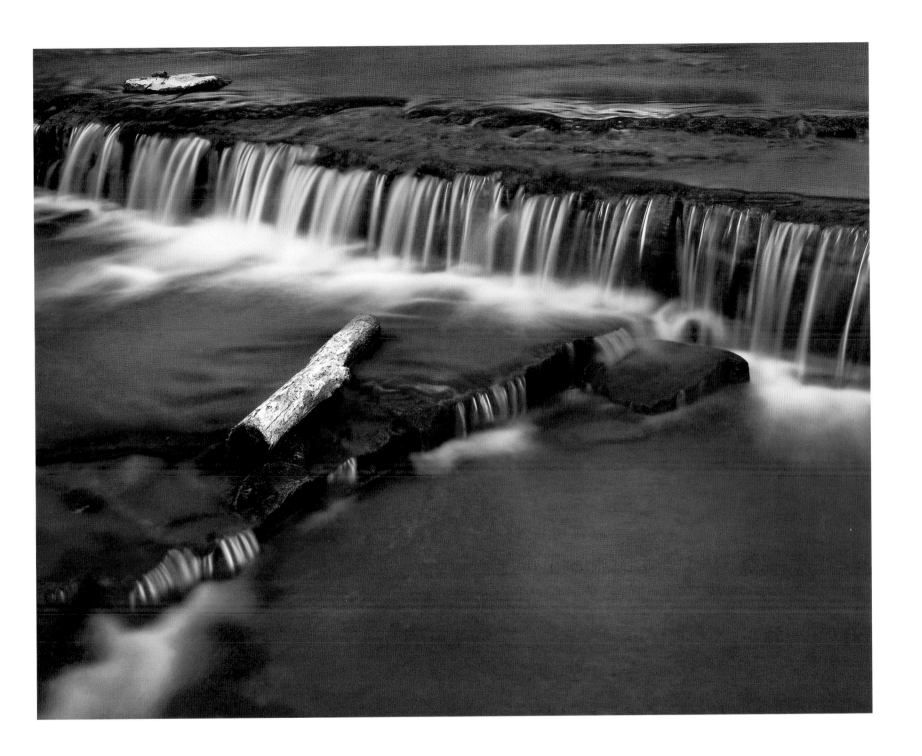

DREAM

PLATE 15

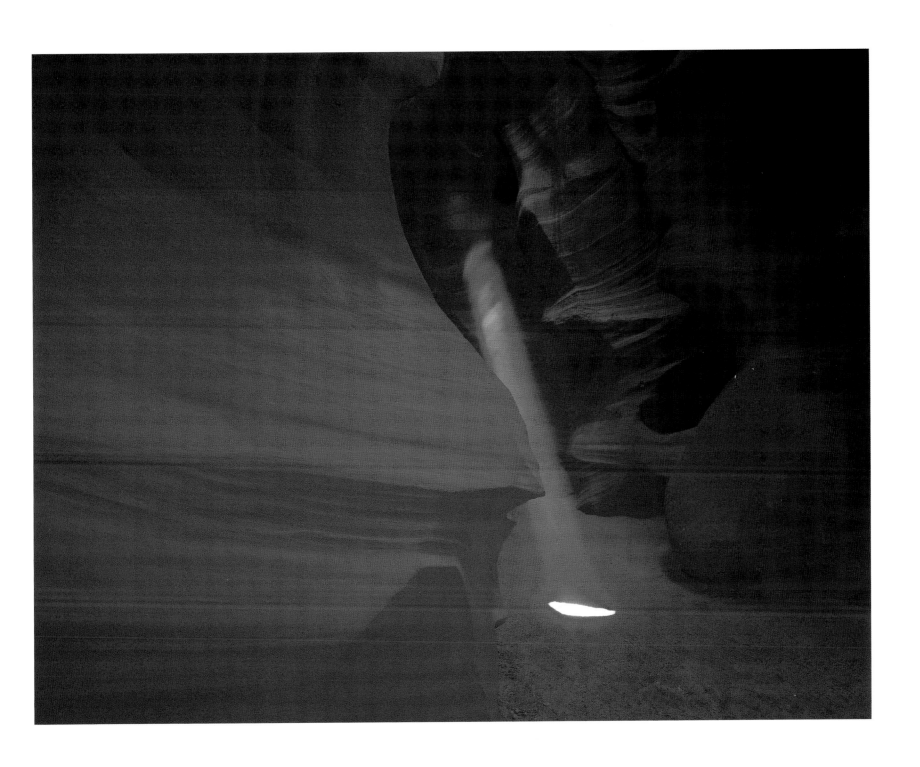

THE LIGHT CATHEDRAL

PLATE 16

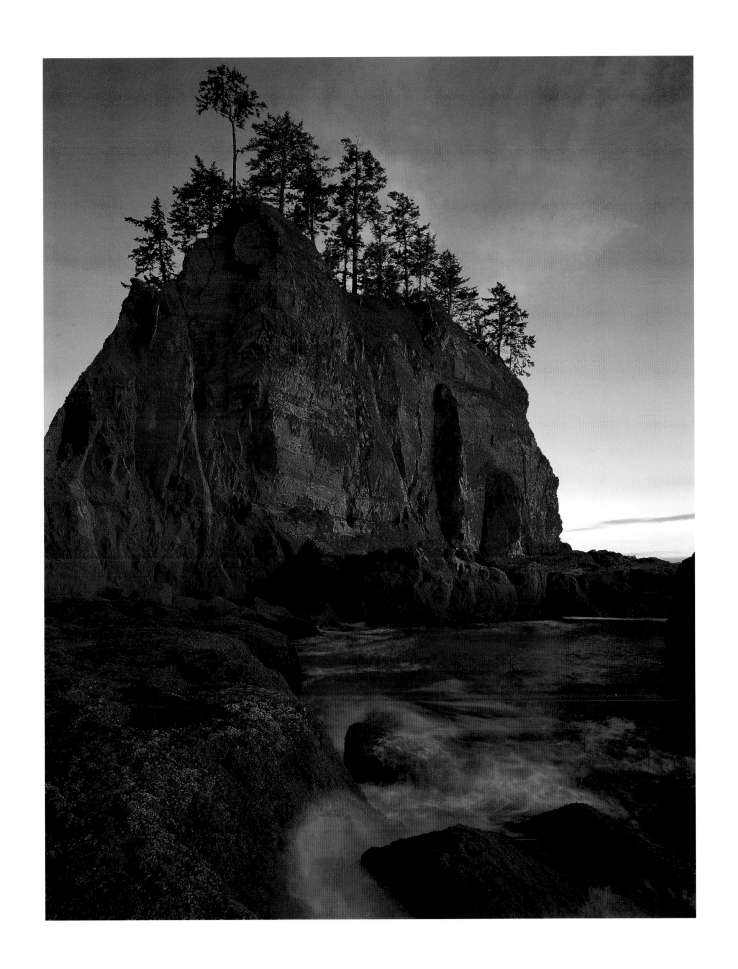

EDGE OF THE SHORE

PLATE 17

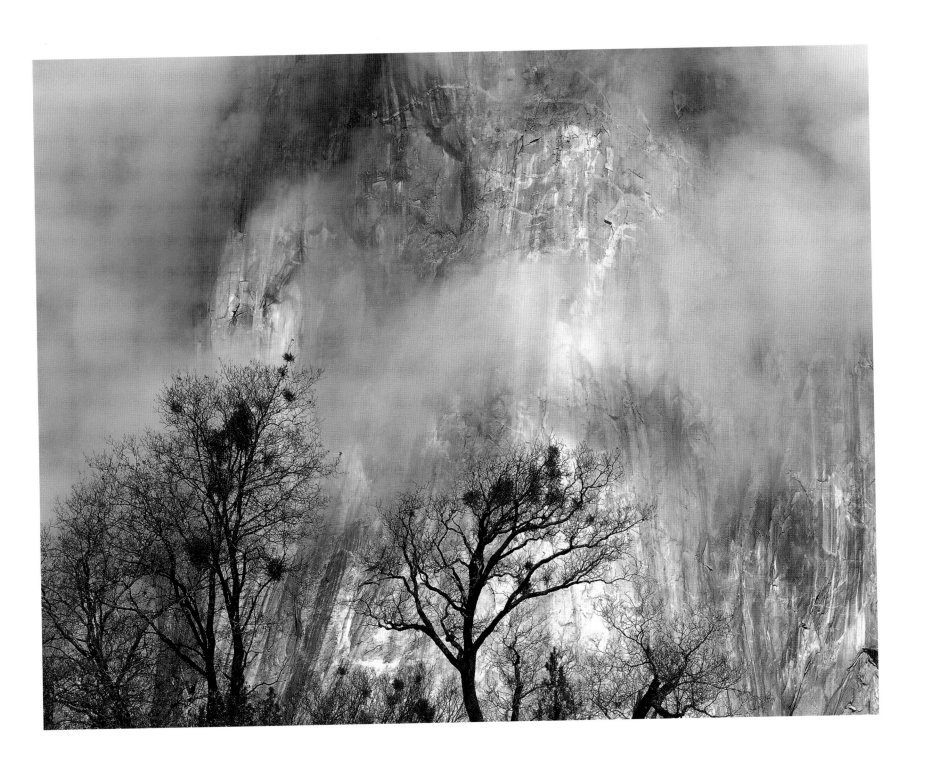

MAJESTIC

PLATE 18

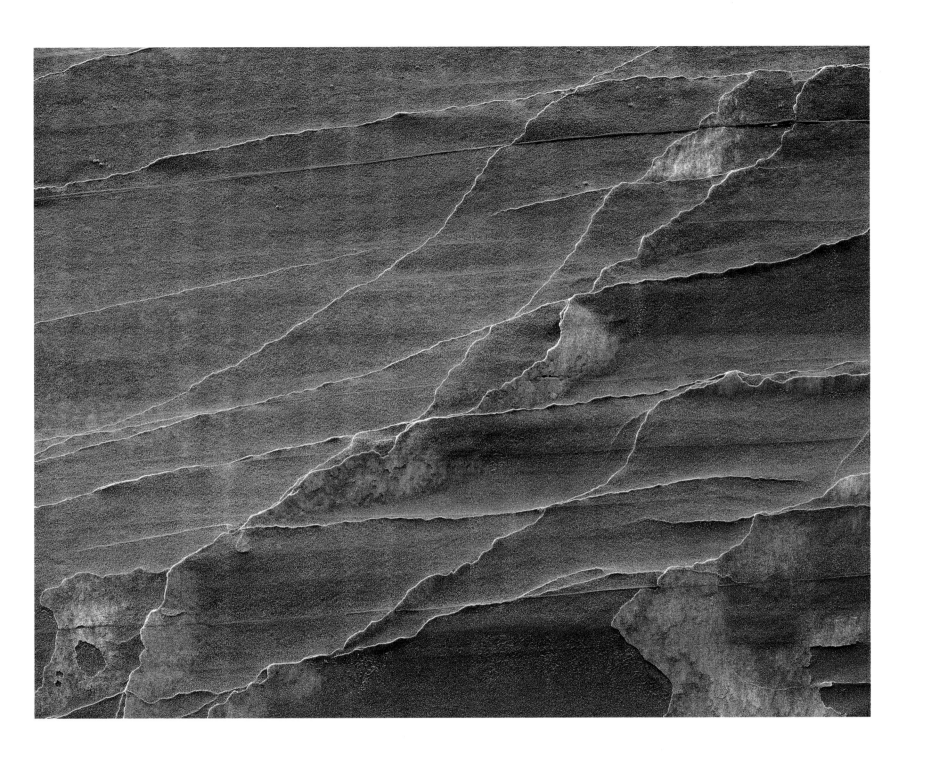

THE MUSIC SHEETS

PLATE 19

Loving you is not from me...
Loving you is all of me.

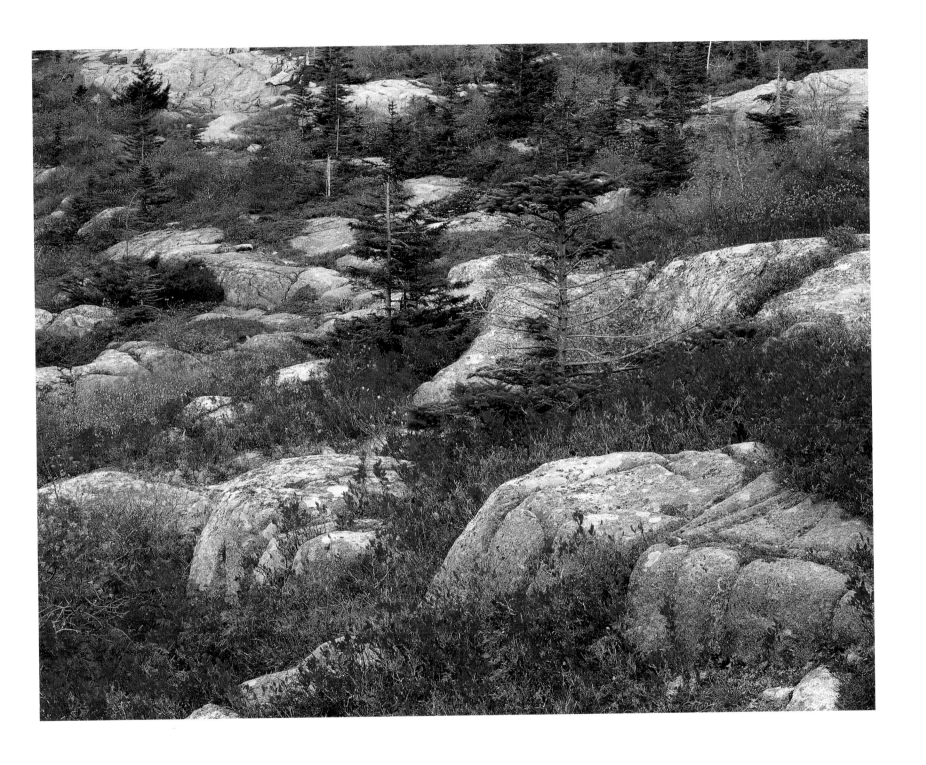

THE SEASON PLAY

PLATE 20

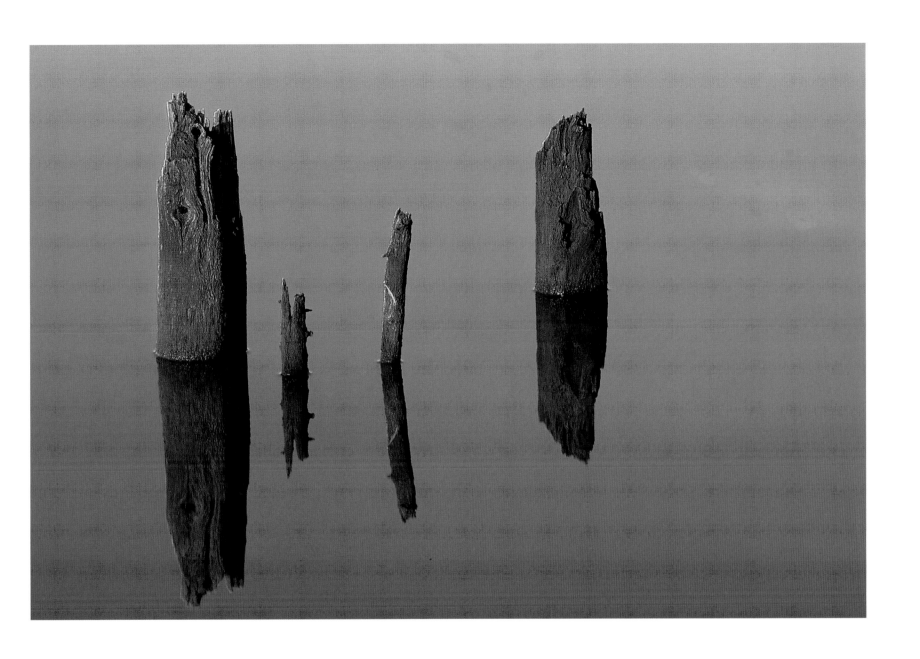

SILENT ECHOS

PLATE 21

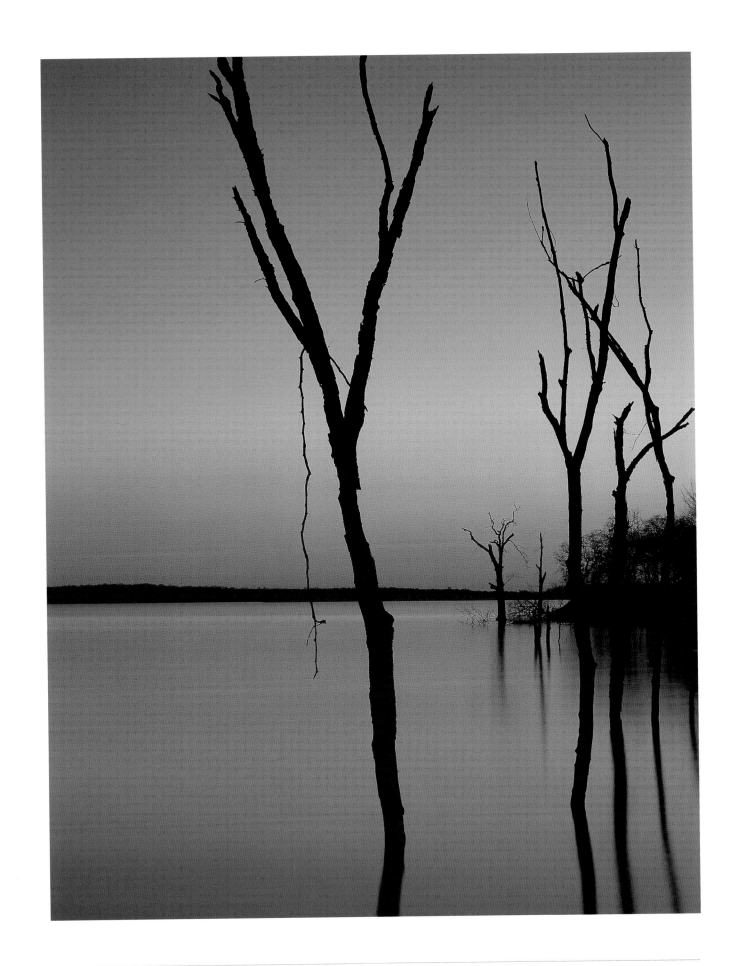

THE DAWN KISS

PLATE 22

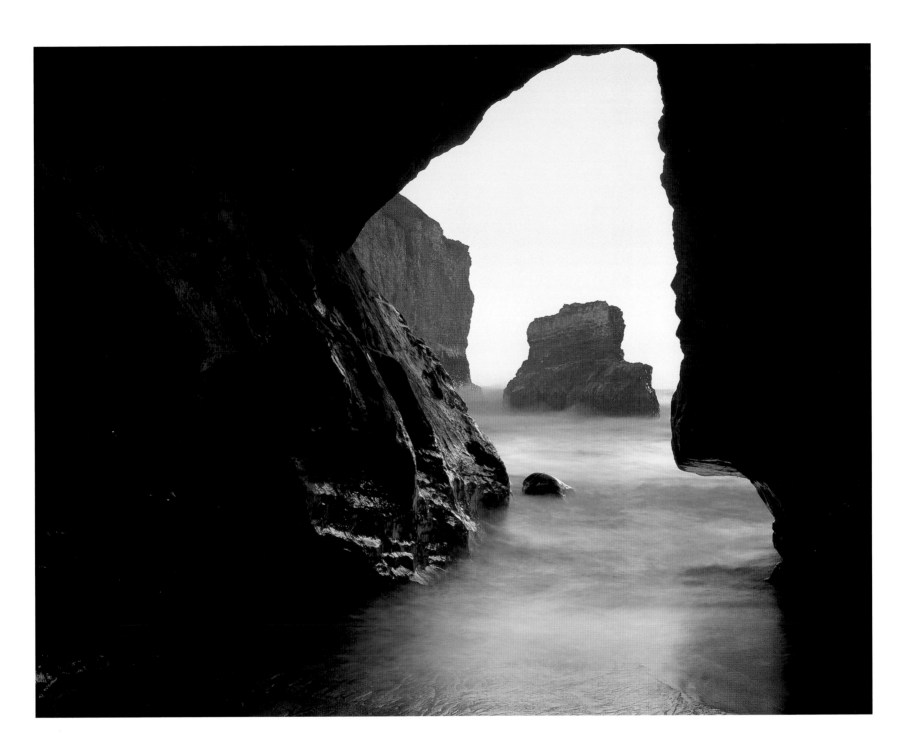

WITHIN

PLATE 23

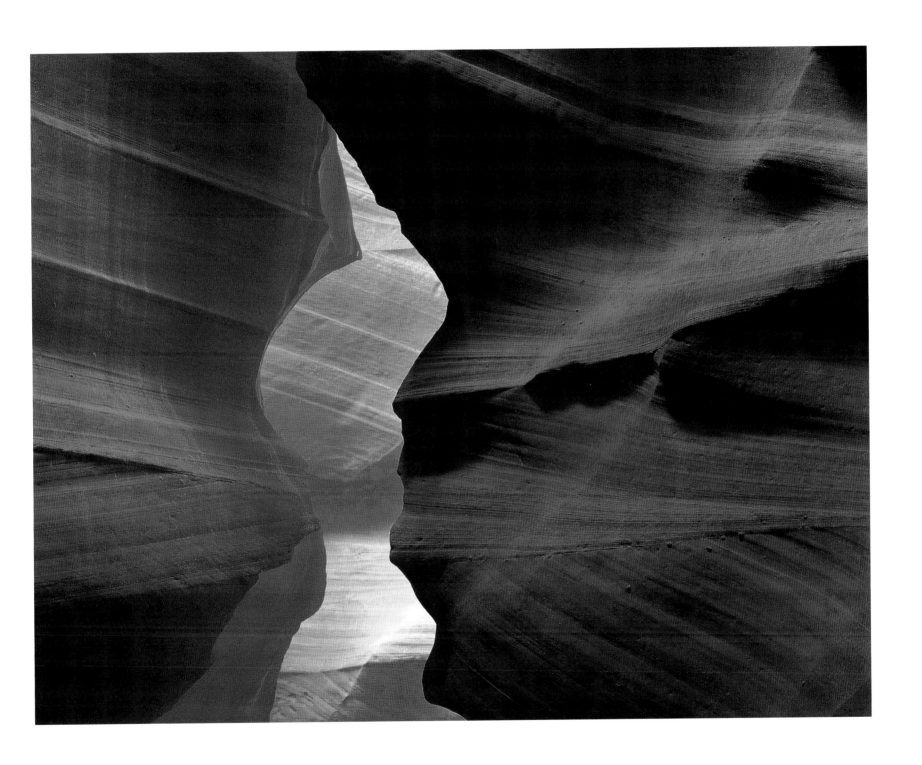

THE PASSIONATE SPIRIT

PLATE 24

I wish I had two hearts.
　　　One for me to live,
　　　　And one for me to love you.

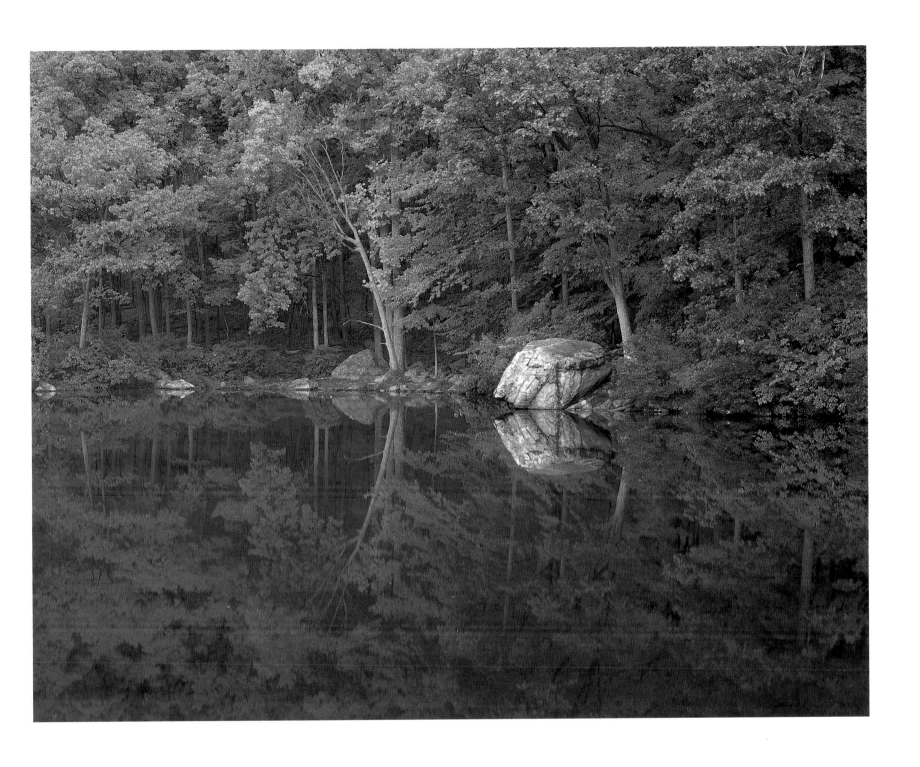

REFLECTION MUSIC

PLATE 25

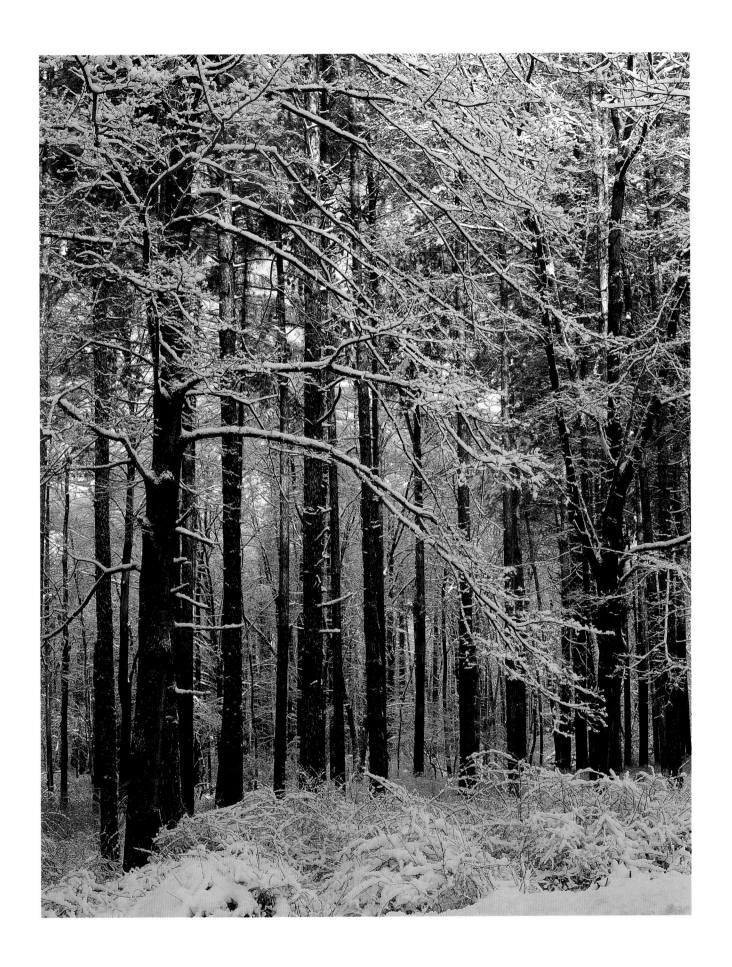

WINTER BEAUTY

PLATE 26

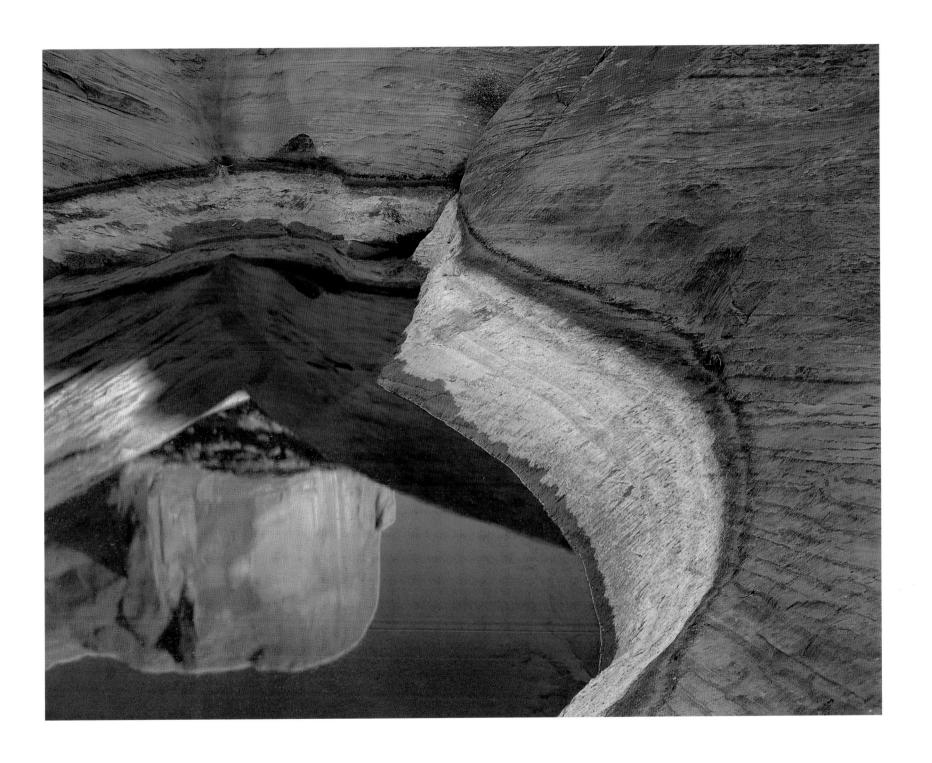

CALM RHYTHM

PLATE 27

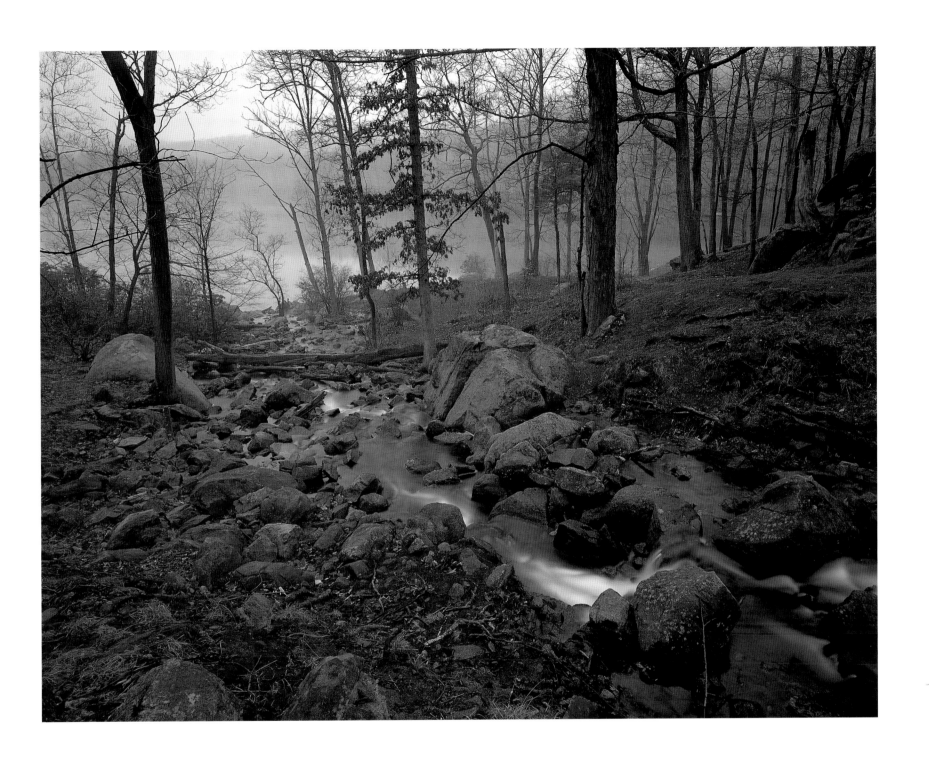

INTIMATE LANDSCAPE

PLATE 28

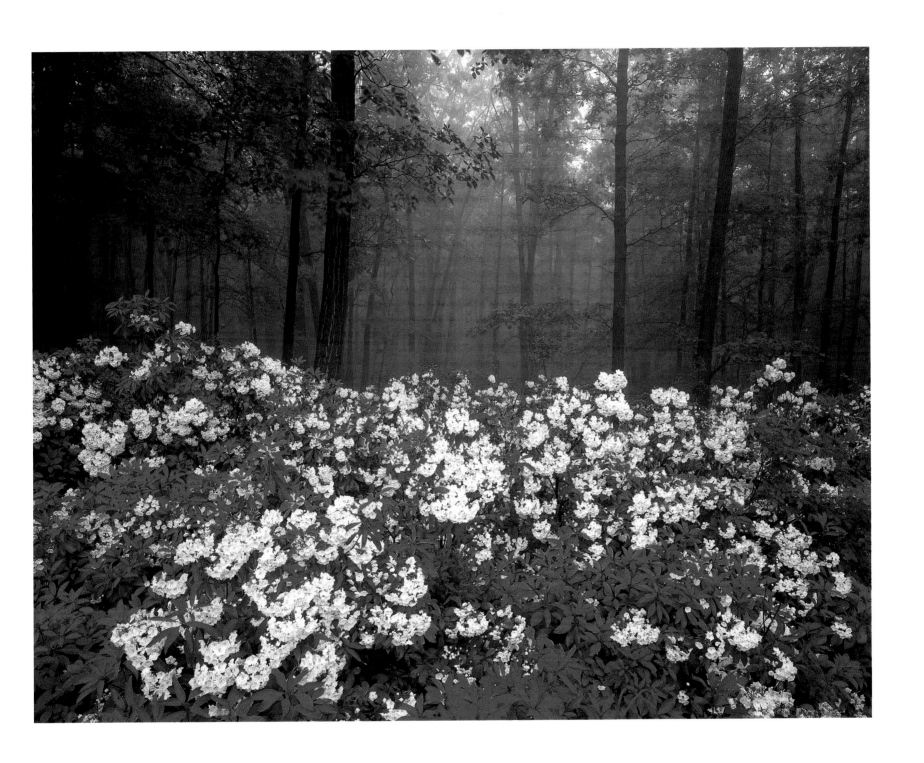

A TOUCH OF BEAUTY

PLATE 29

If we just listen,
we might hear
the Voices of Light.

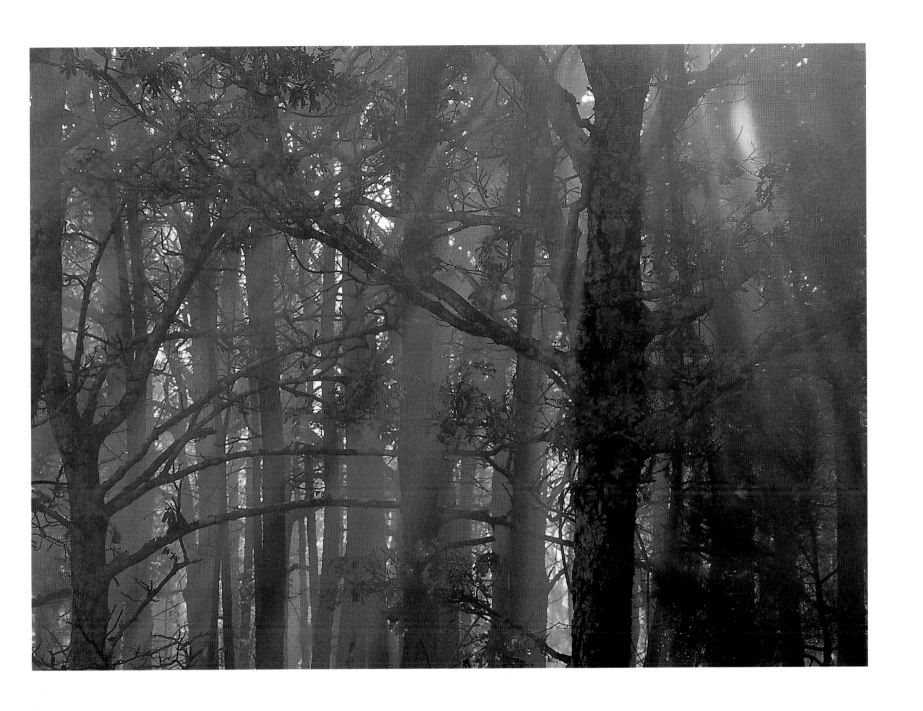

LISTEN TO THE LIGHT

PLATE 30

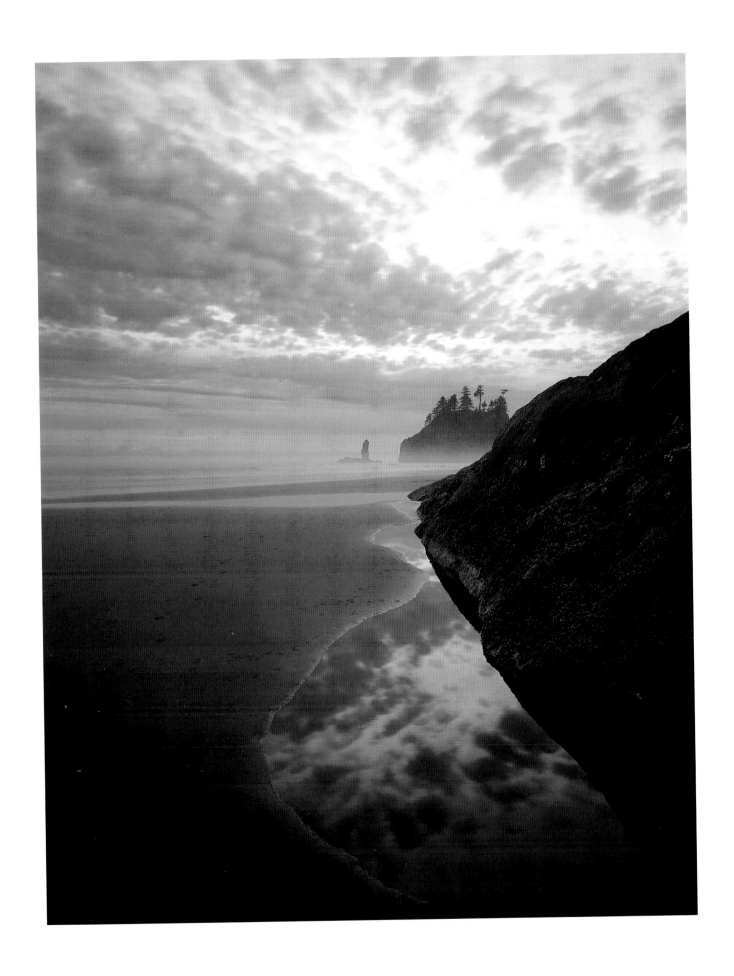

PEACEFUL SEA

PLATE 31

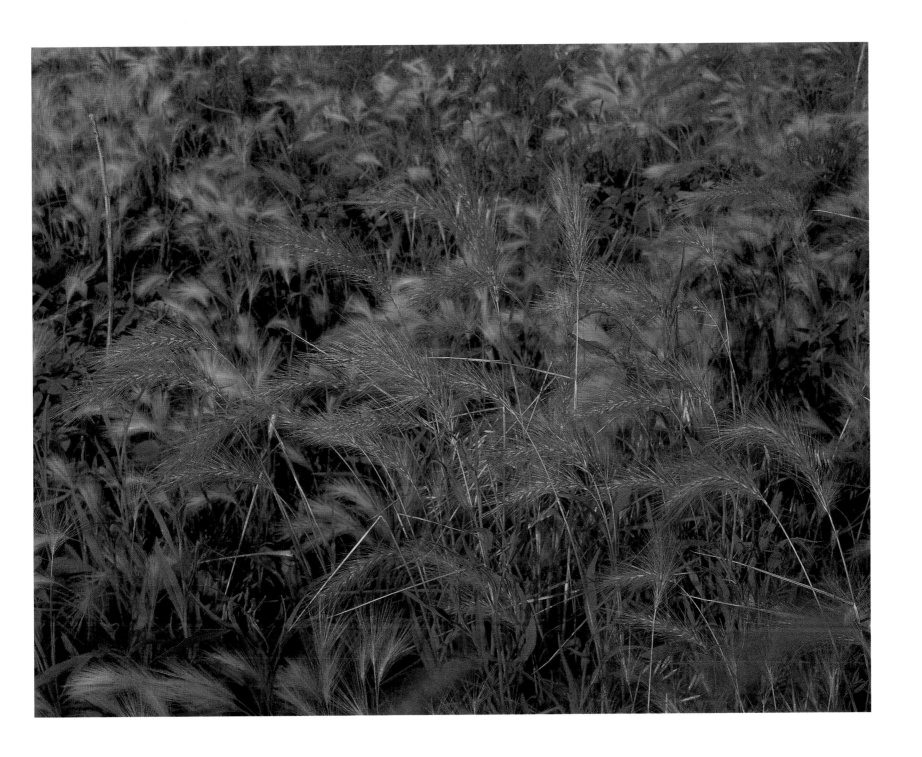

MELTING AWAY

PLATE 32

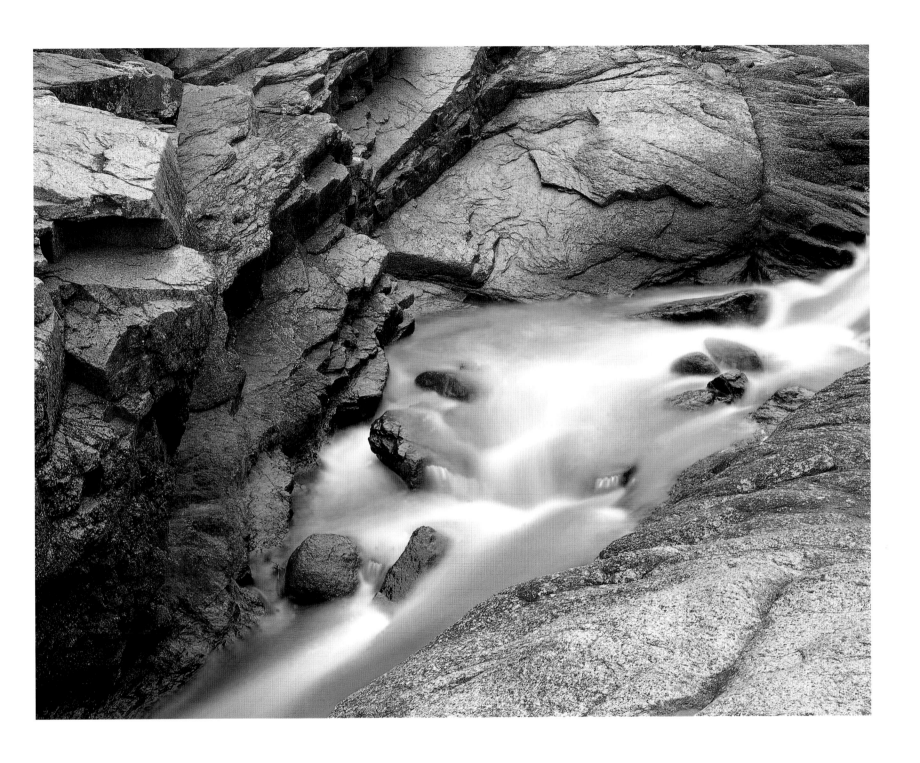

PASSAGE OF TIME

PLATE 33

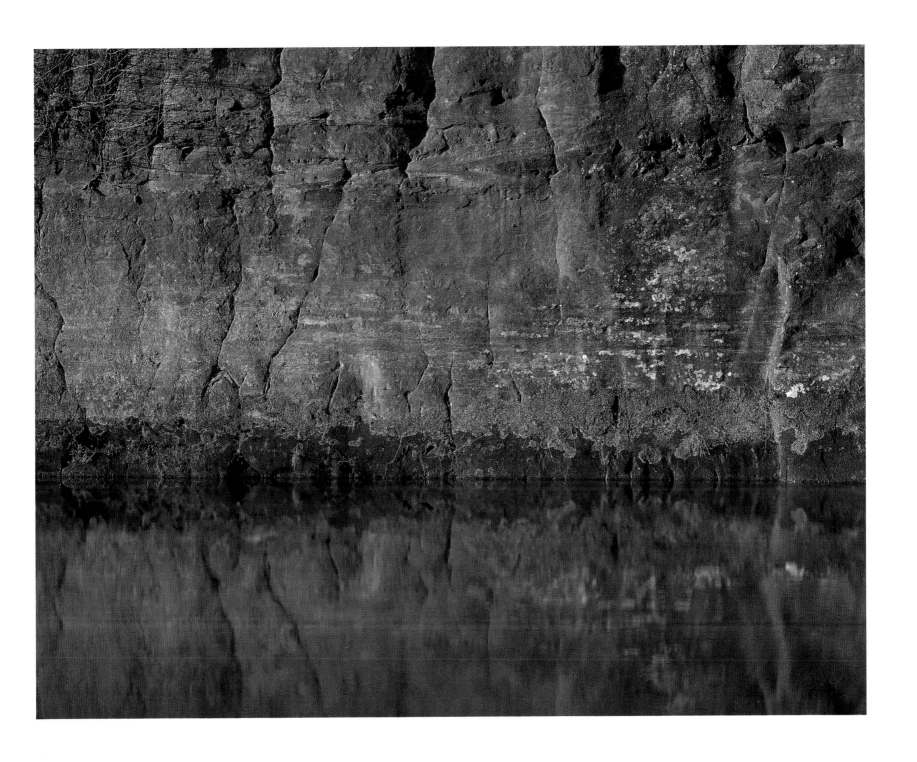

SILENT WALLS

PLATE 34

The day I met you
 is my birthday.
Let me love you,
 let me adore you,
 my way.

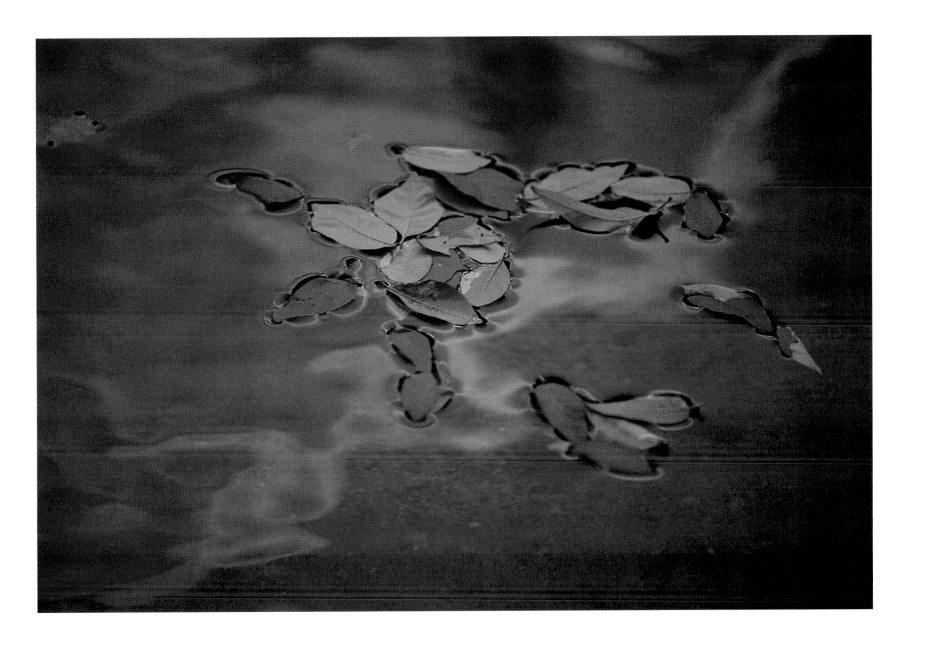

DANCING LEAVES

PLATE 35

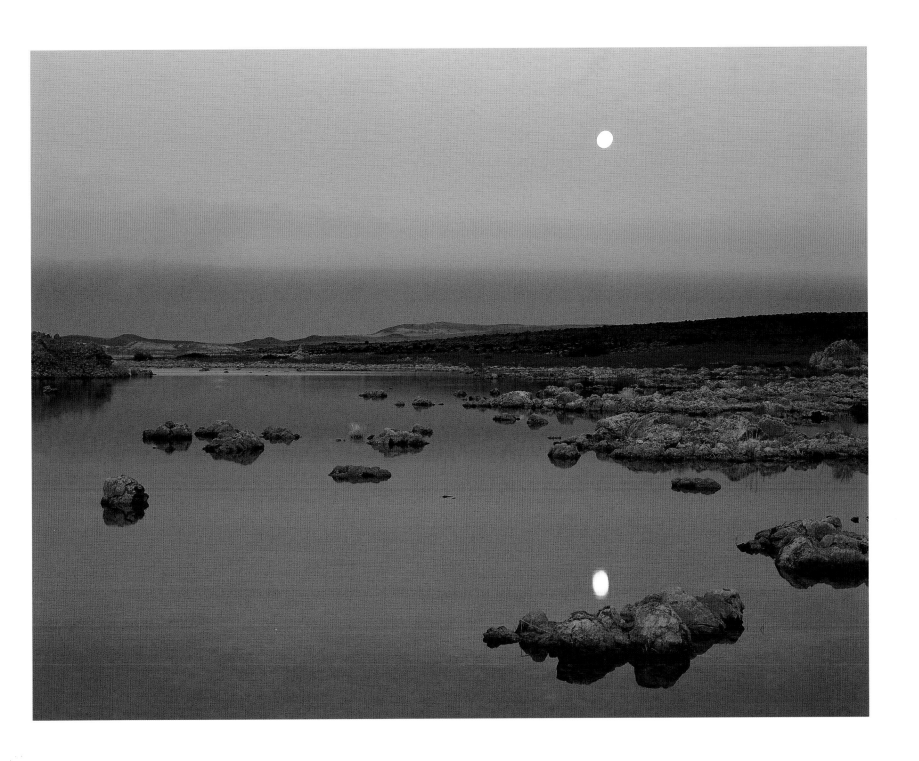

MYSTICAL DUSK

PLATE 36

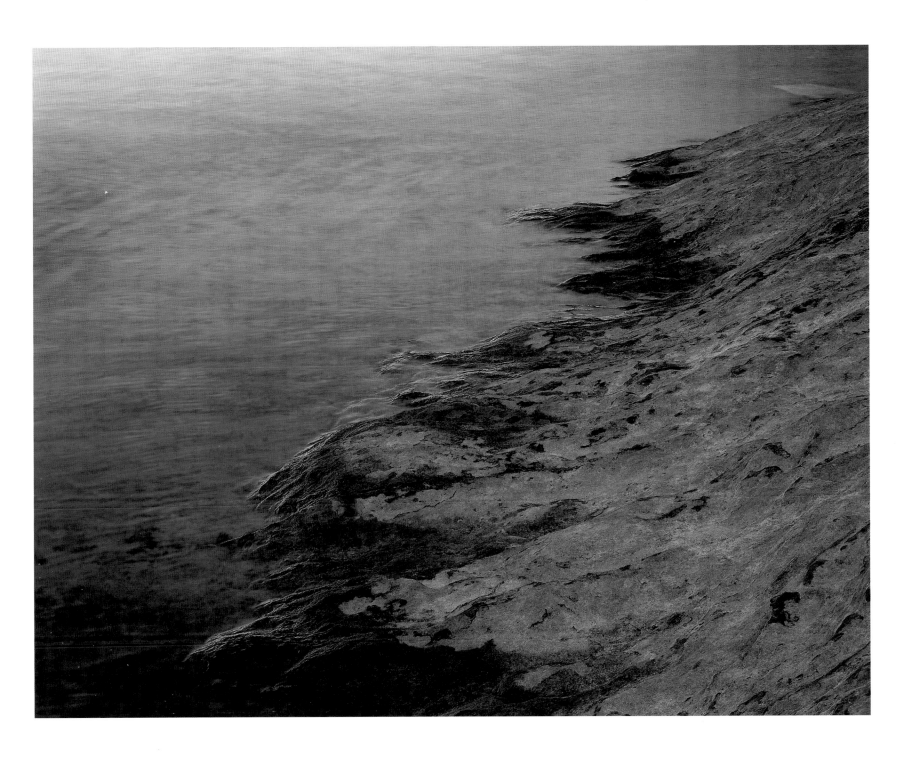

FADING MEMORIES

PLATE 37

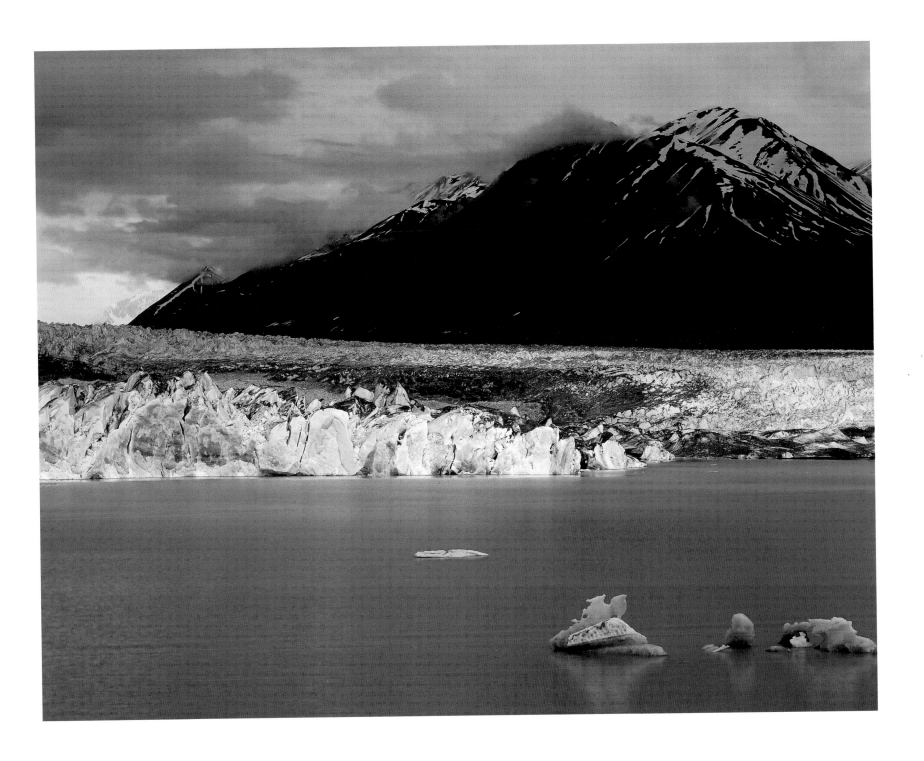

THE STAGE

PLATE 38

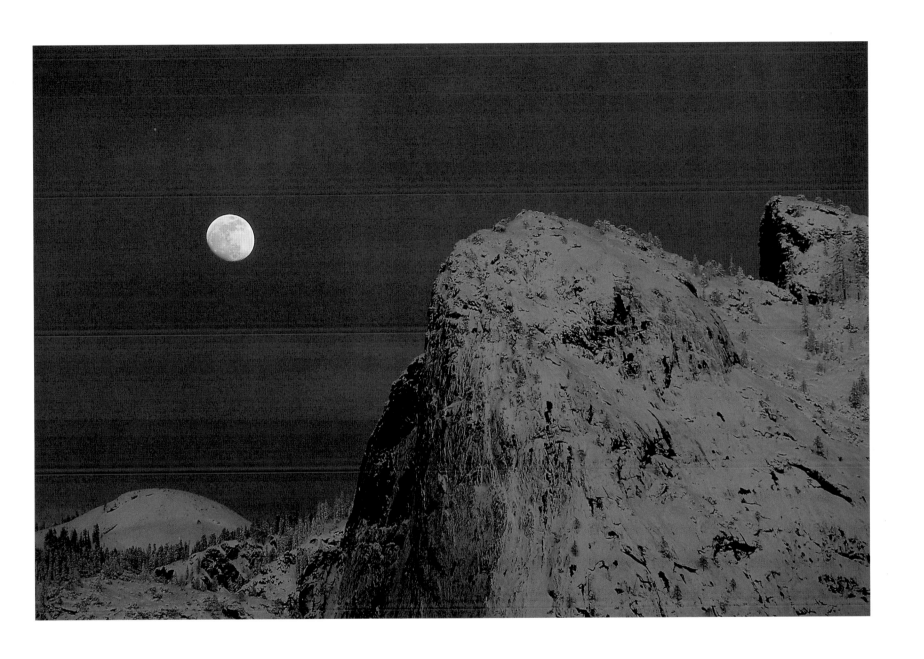

THE NIGHT LIGHT

PLATE 39

Nights under the poetry tree,
Into the wild my heart is free,
Searching for you inside me,
Between my poetry papers, I found thee.

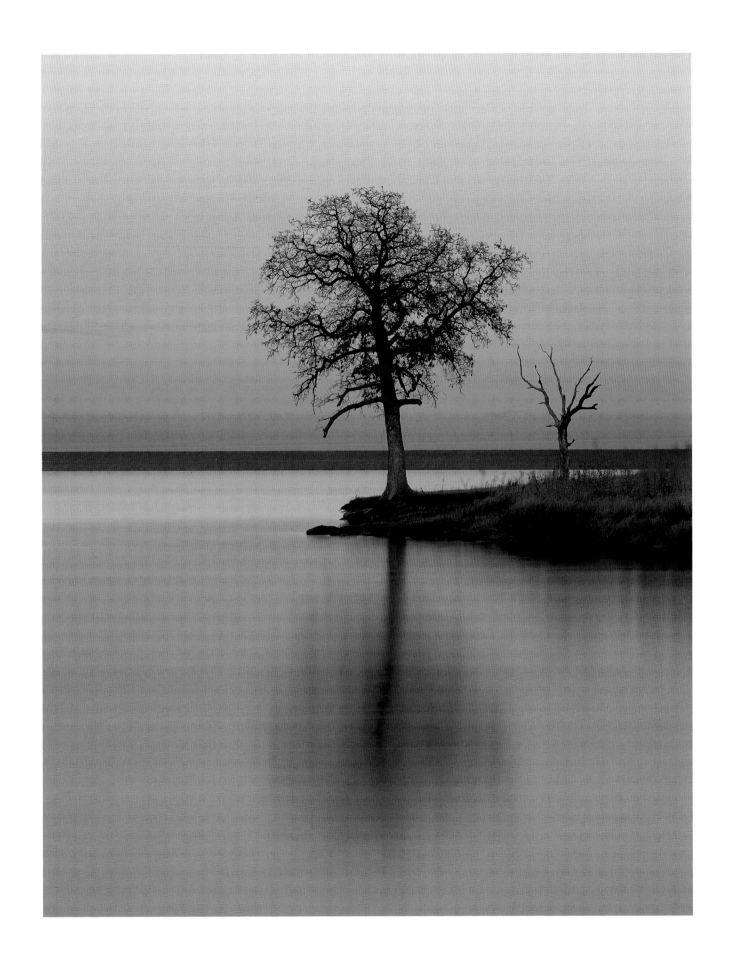

POETRY TREE

PLATE 40

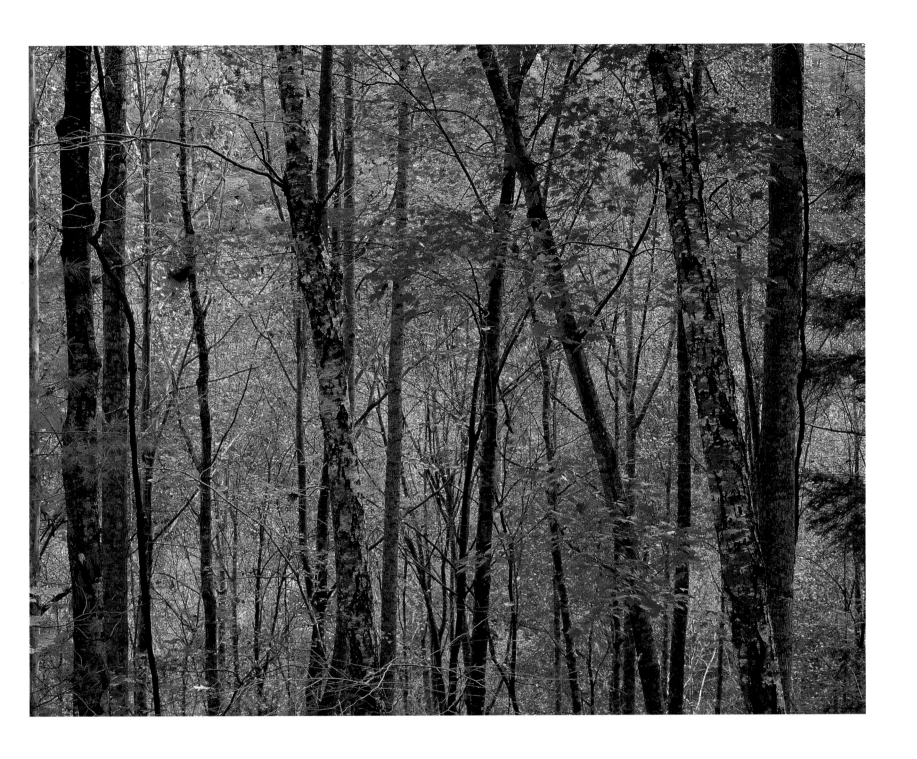

AUTUMN PALETTE

PLATE 41

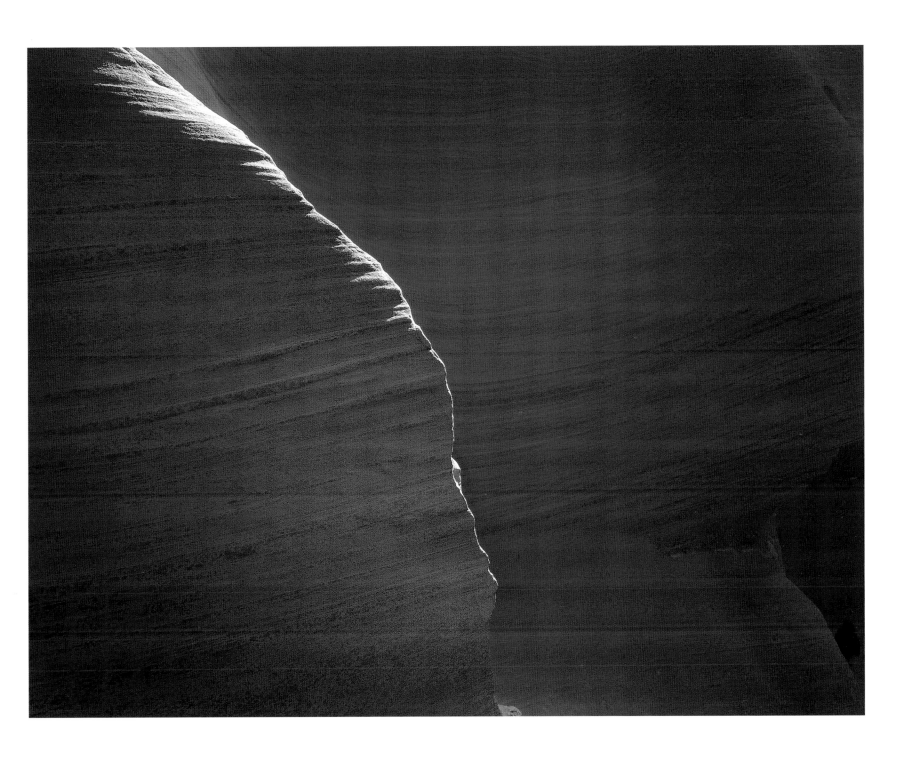

AT THE EDGE

PLATE 42

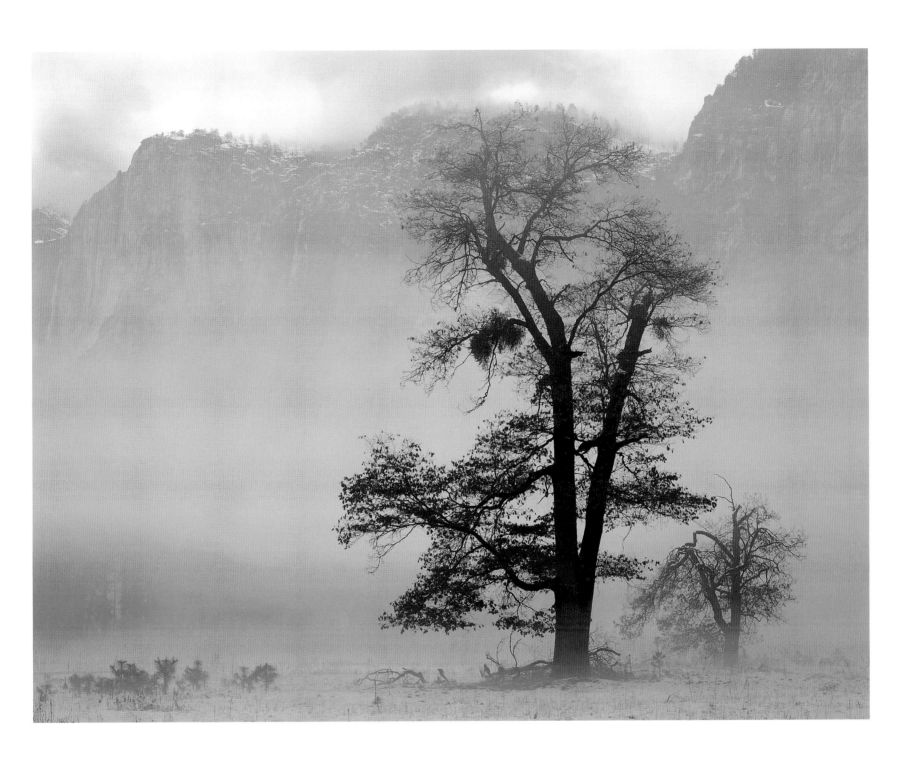

VALLEY OF PEACE

PLATE 43

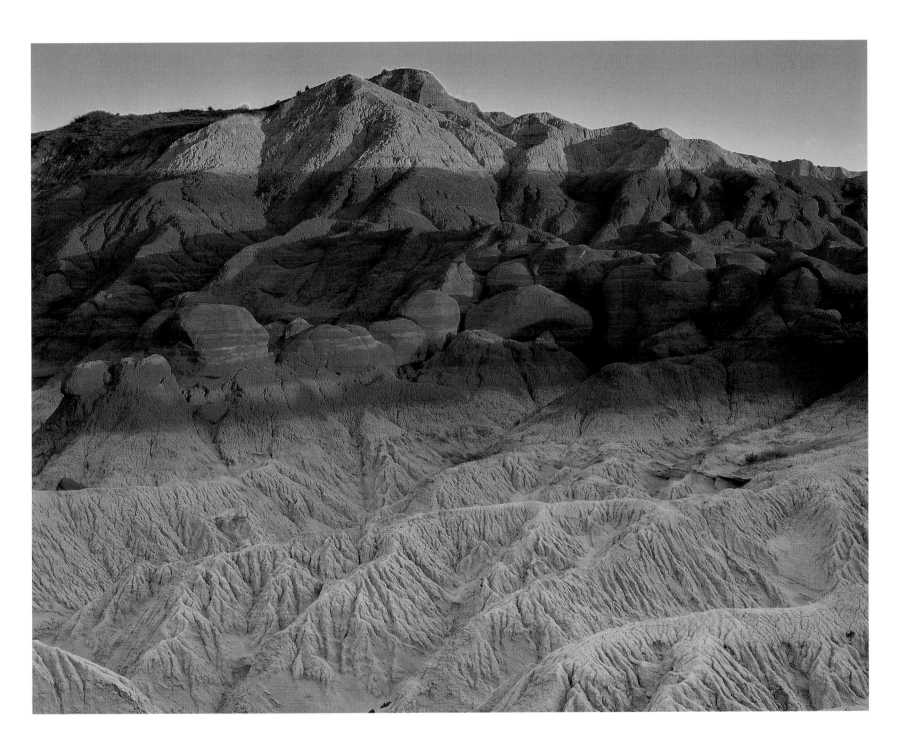

ETERNAL LAND

PLATE 44

Like the kids we laughed;
* like the kids we played.*
We ran in a trail of happiness;
* we ran so fast,*
* we passed our shadows.*

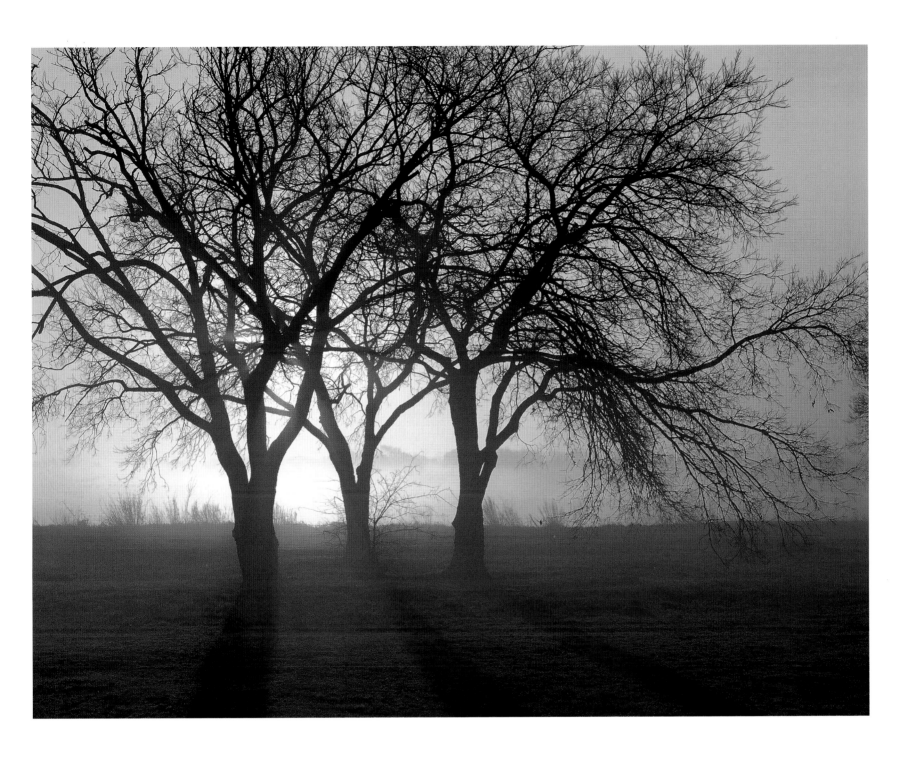

SUNDANCE

PLATE 45

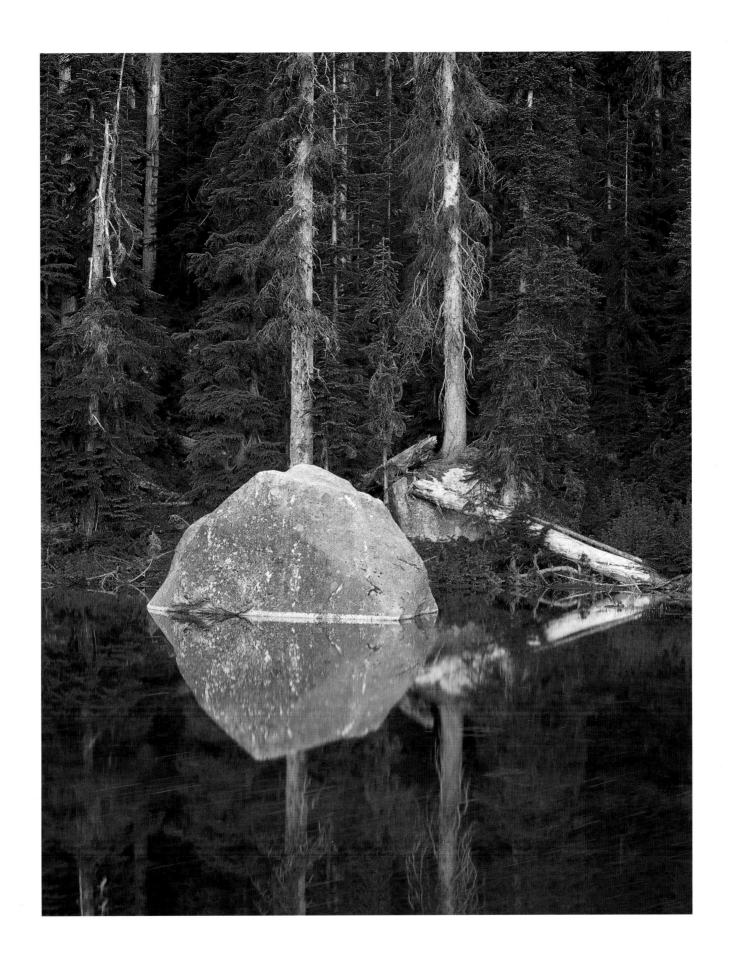

PASSIONATE REFLECTIONS

PLATE 46

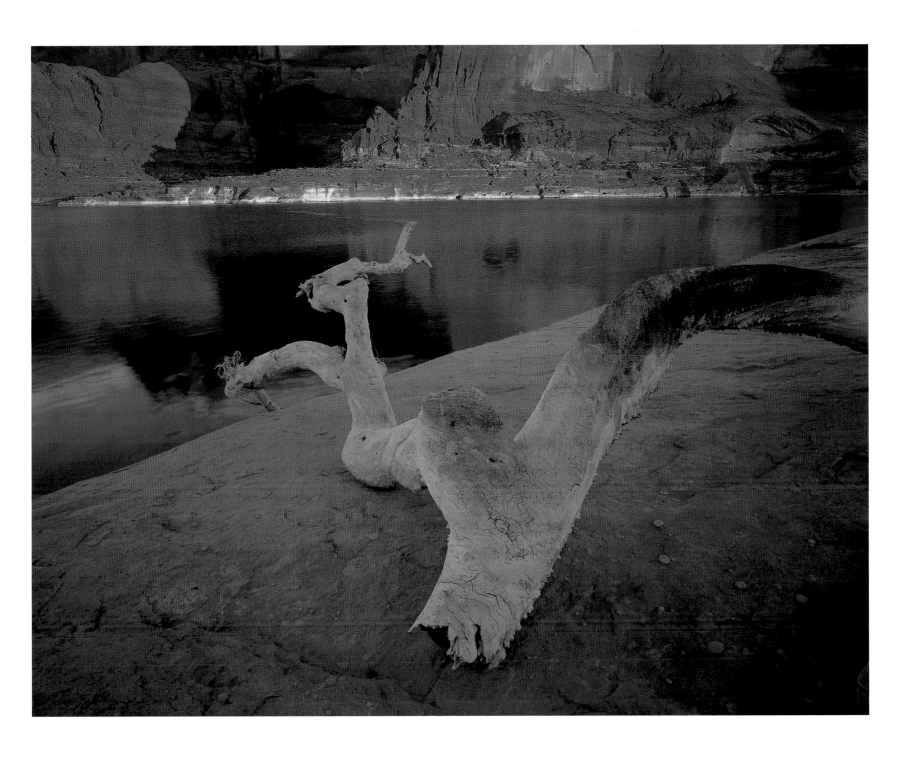

ESCAPE

PLATE 47

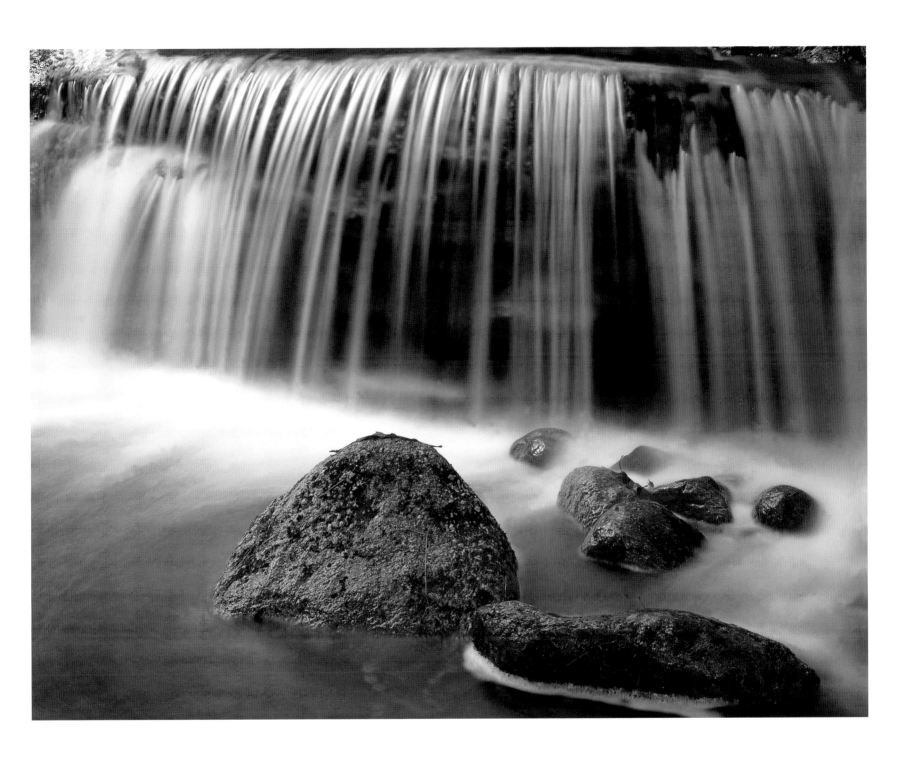

CRYSTAL CASCADES

PLATE 48

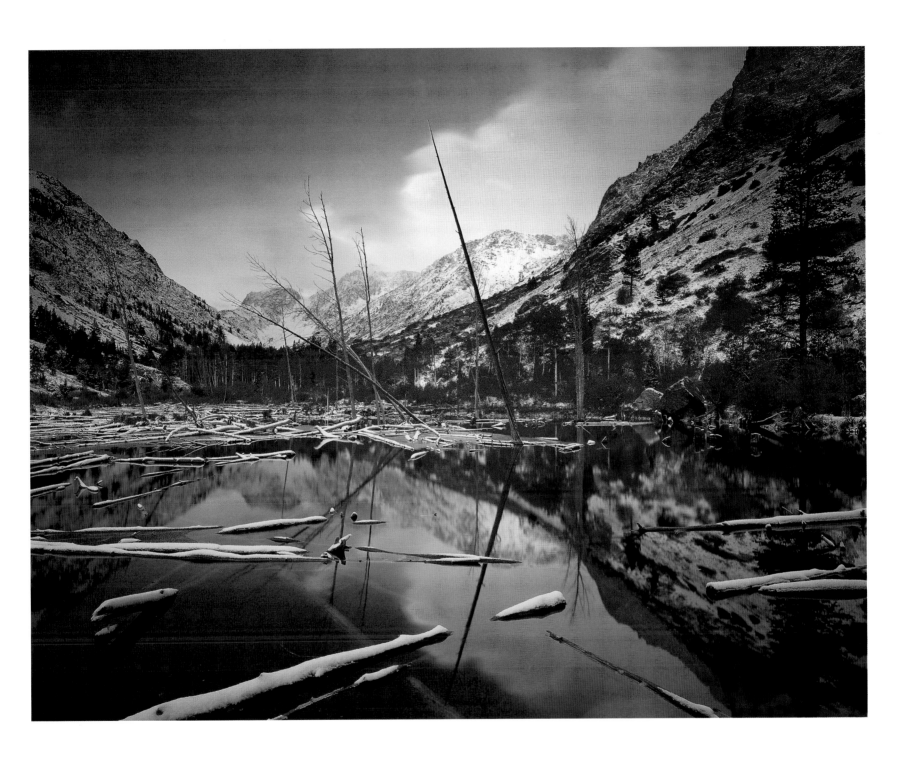

REFLECTION DANCE

PLATE 49

Ask the flowers, "What are your colors?"
Ask the time, "How fast are the hours?"
Ask the heart, "Why do we get jealous?"

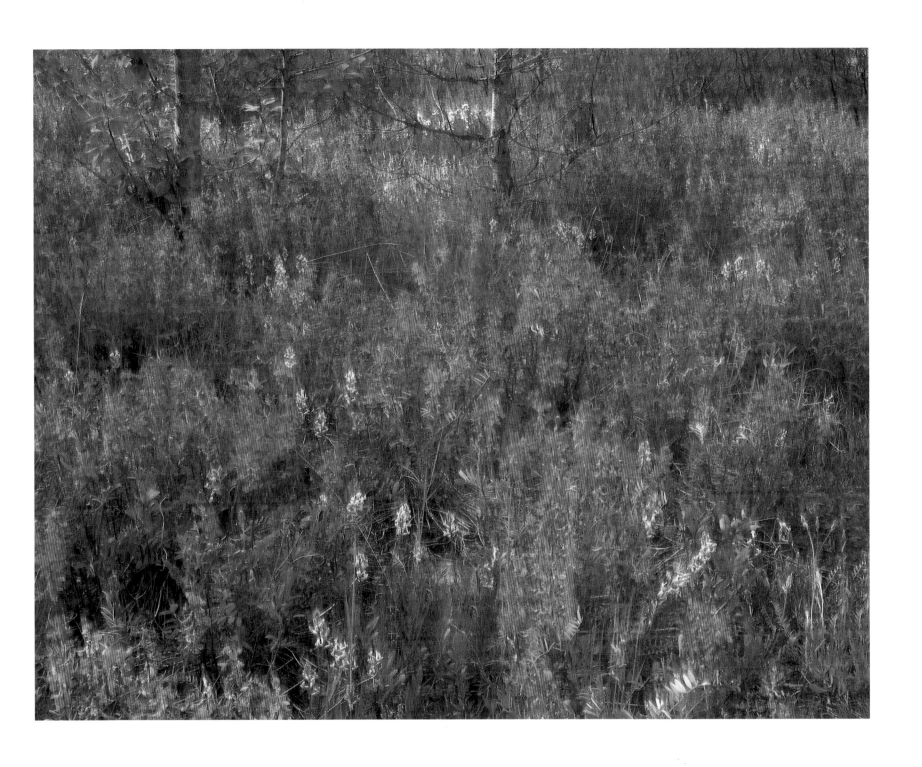

PLAY WITH THE WIND

PLATE 50

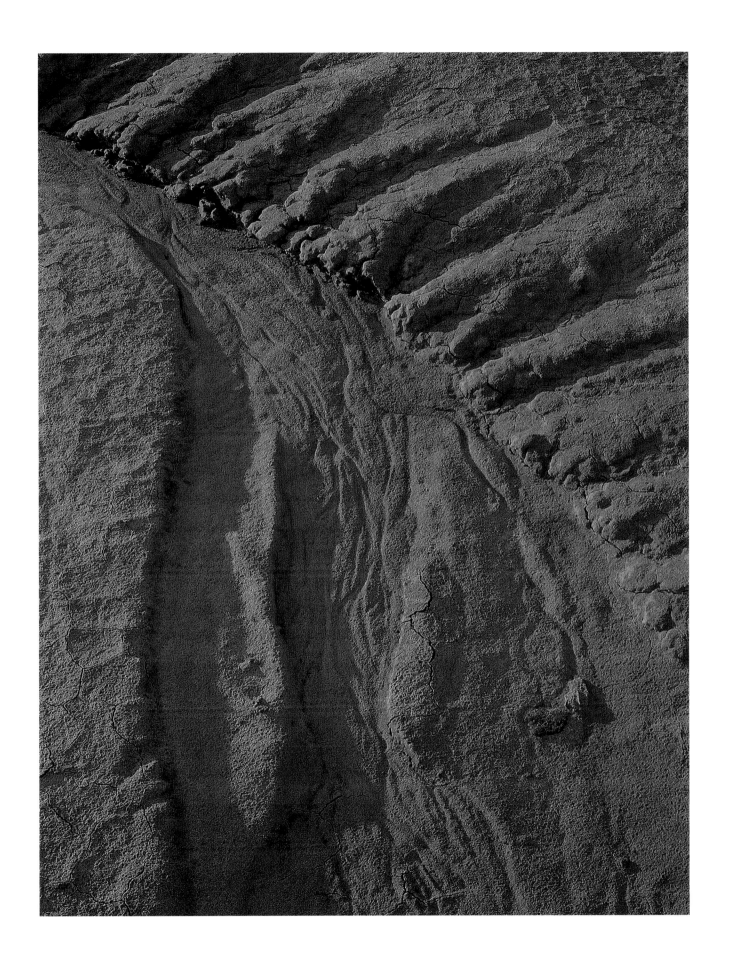

STREAM OF TEARS

PLATE 51

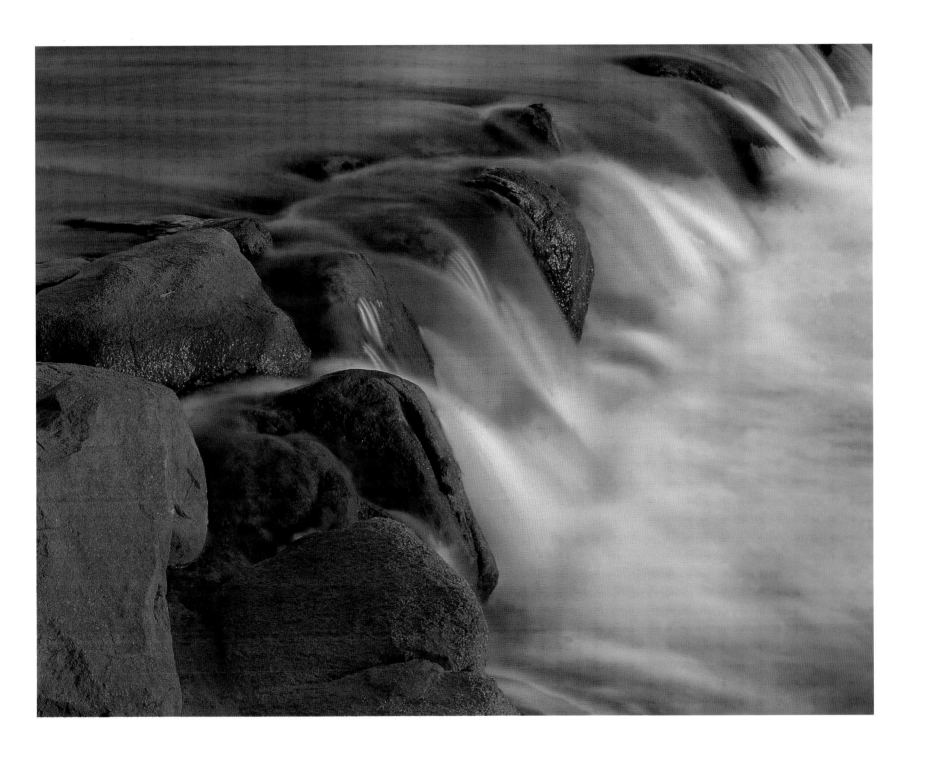

FLOWING MELODIES

PLATE 52

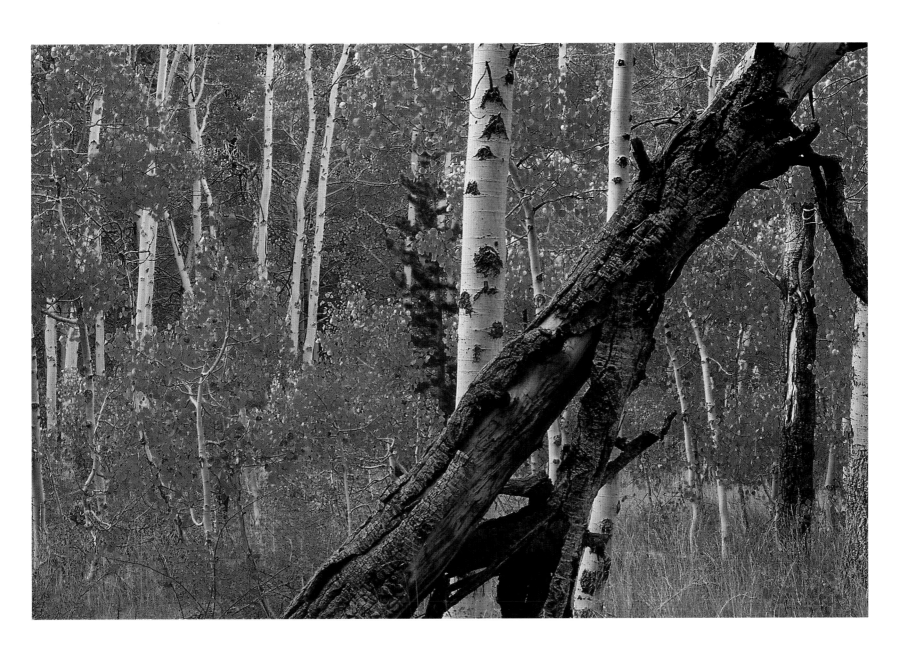

AUTUMN SOLITUDE

PLATE 53

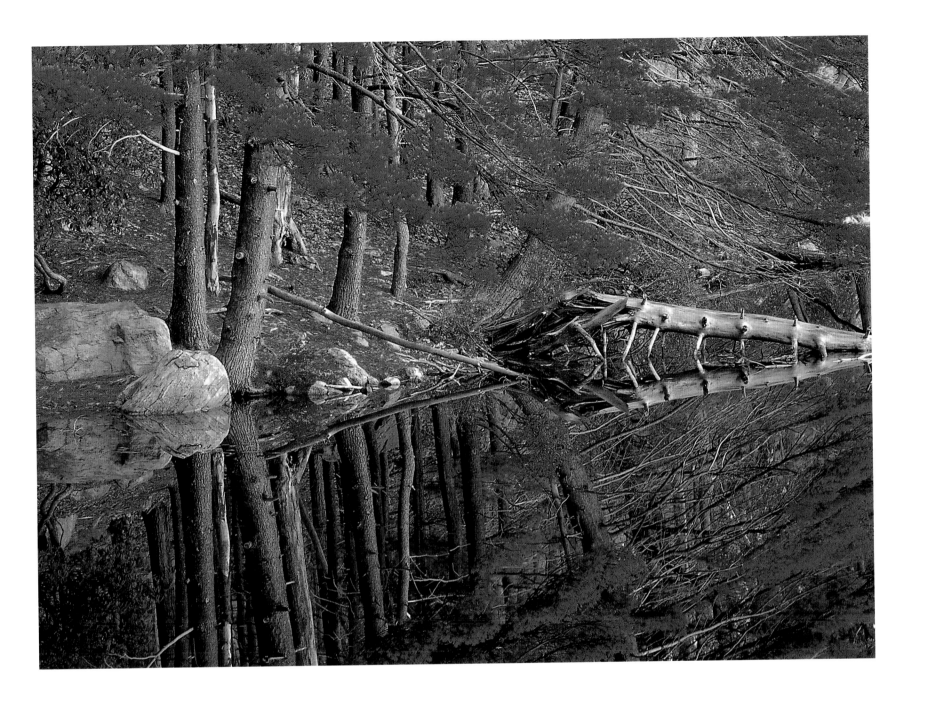

ECHO'S SONG

PLATE 54

Have you run into my forest
 and made it your palace?
Have you made the grass your bed
 and the stars your covers?
Have you listened to the silence
 and danced with the flowers?
Have you showered with my fragrance
 and dried with my rays?

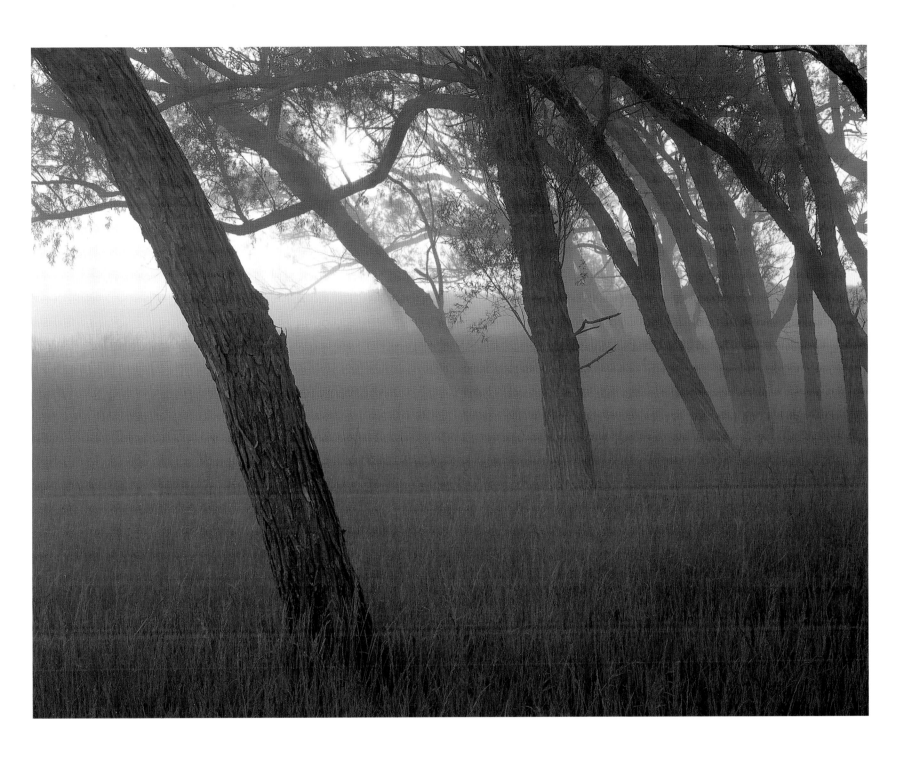

SERENE

PLATE 55

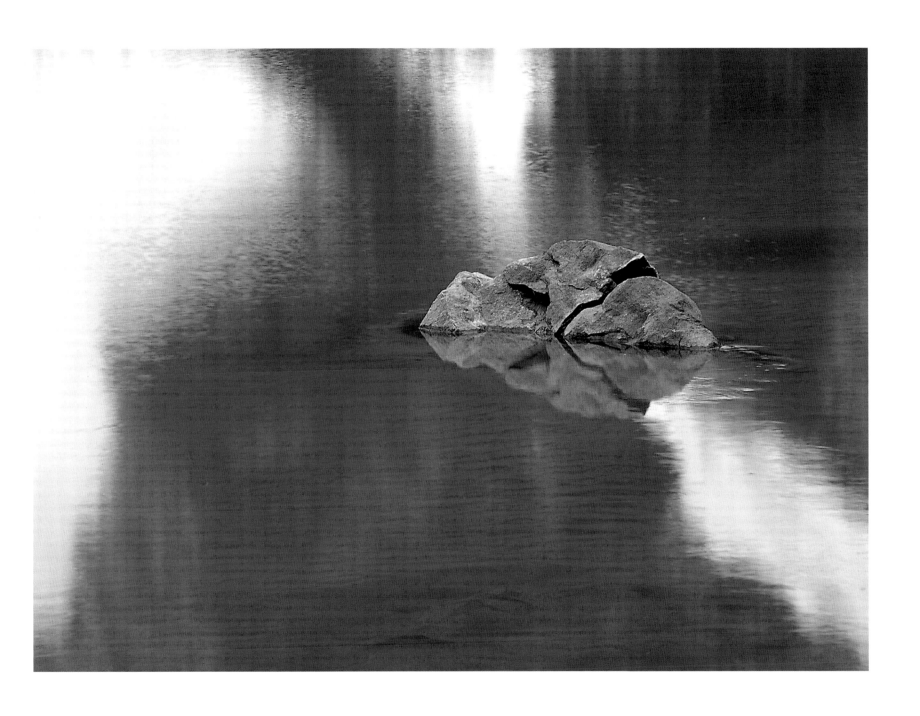

QUIET MEADOWS

PLATE 56

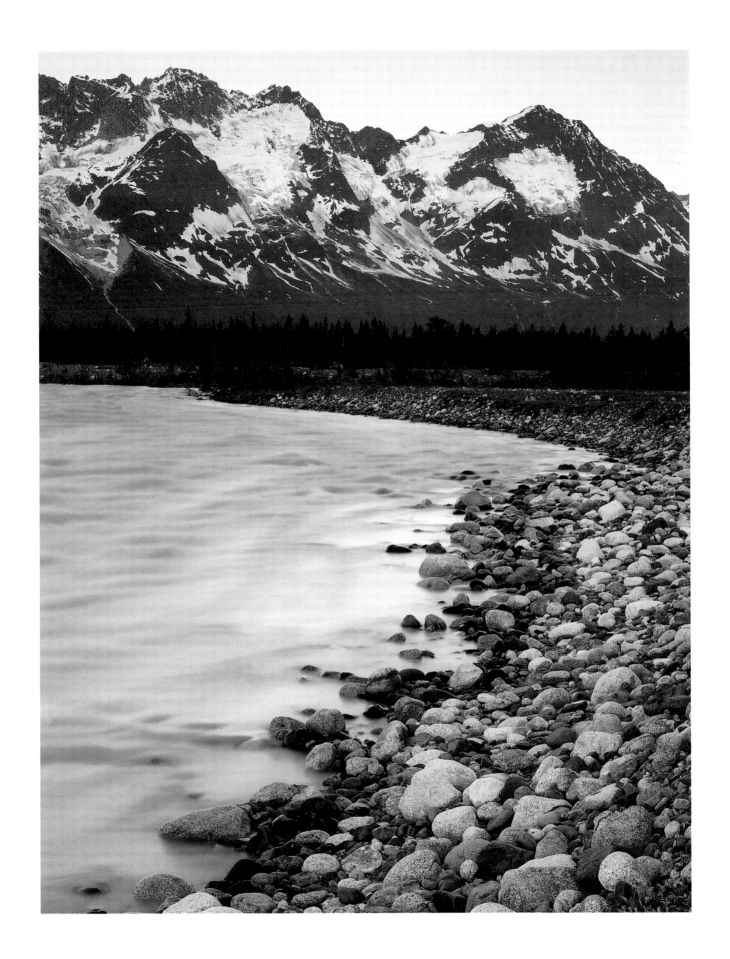

LANDSCAPE SYMPHONY

PLATE 57

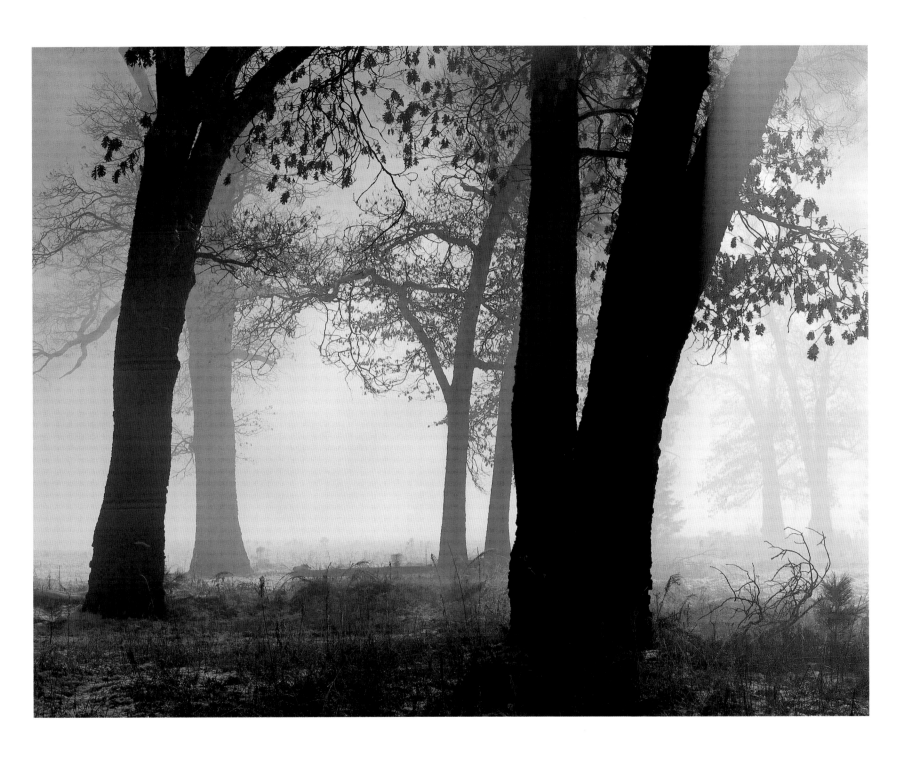

DARKNESS FIBERS

PLATE 58

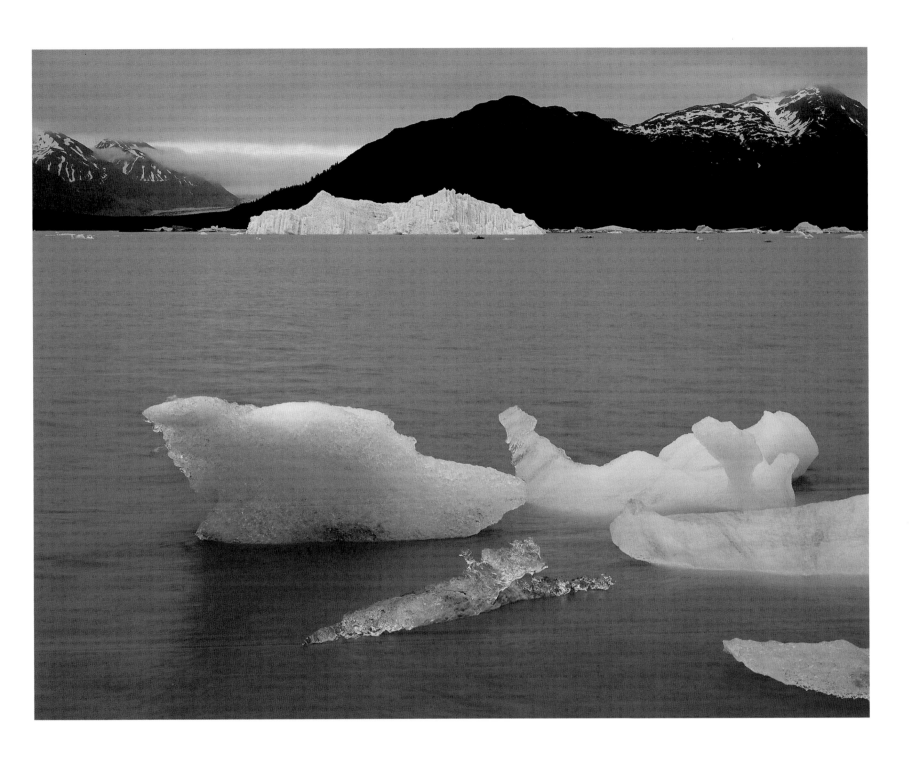

SOUND OF SILENCE

PLATE 59

Peace to all.

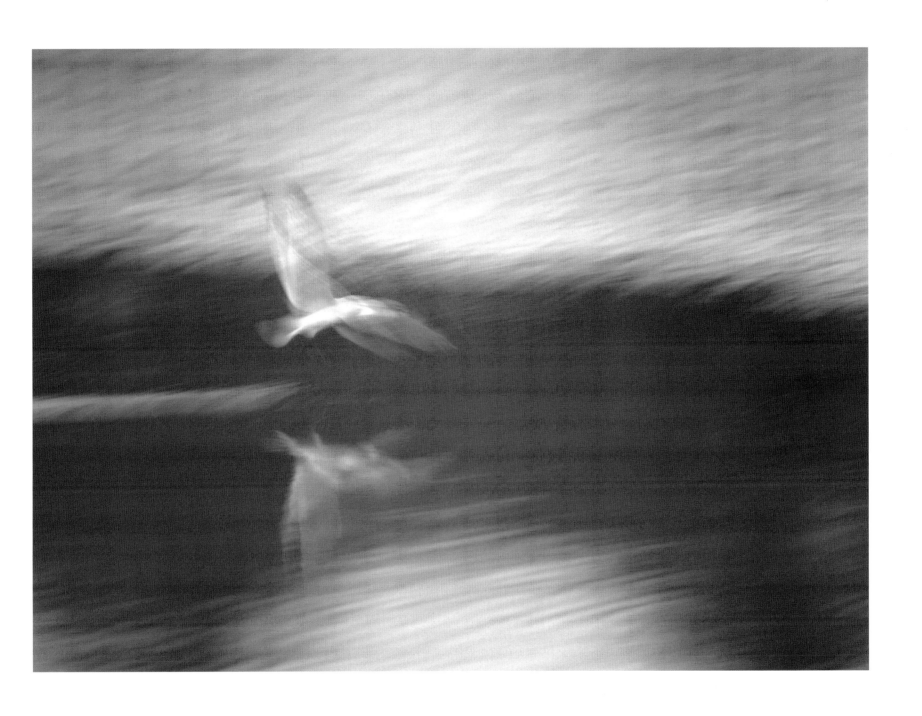

IN SEARCH OF PEACE

PLATE 60

LIST OF PLATES

ACKNOWLEDGMENT

Throughout my life, growing up around the world, I have been extremely fortunate to meet so many friends, which are treasured gifts in my life. To express individual appreciation to all of my family and friends would require more than a page or book chapter. You all know who you are and how much I appreciate your friendship. I, too, am proud and feel honored to have been invited into your lives and considered your friend.

Silently, I would like to express a heartfelt thank you to all my family and friends with whom I work, travel, hike and photograph.